TECHNIQUES FOR
BLACK & WHITE
PHOTOGRAPHY

CREATIVITY AND DESIGN

ROGER FREMIER
AMHERST MEDIA, INC. ■ BUFFALO, NY

Copyright © 2000 by Roger Fremier.
All rights reserved.

All photographs by the author.
All drawings courtesy of Eldon Dedini.

Published by:
Amherst Media, Inc.
P.O. Box 586
Buffalo, N.Y. 14226
Fax: 716-874-4508
www.AmherstMedia.com

Publisher: Craig Alesse
Senior Editor/Production Manager: Michelle Perkins

ISBN: 1-58428-033-6
Library of Congress Card Catalog Number: 00-132632

Printed in the United States of America.
10 9 8 7 6 5 4 3 2 1

Table of Contents

Preface

The purpose of this book is to start you on your way to making more creative photographs. It gives you a simple, but broad method to apply your ideas to a visual problem. It allows you to consider the vast approaches to photography from technical, compositional and expressive aspects.

Begin by following the creative approach as described and then applying it in your own way. Start very procedurally and then approach photography with more metaphysical concerns. Plug yourself into this method and let the electrical current take you on your own journey.

I am indebted to Alex Osborn for a grant from the Creative Educational Foundation and Dr. M. O. E. Edwards who allowed me to teach with him. Both gave me the opportunity to start teaching creativity and begin my journey in studying the creative process.

I am grateful to the following people for their encouragement in photography: Ansel Adams; Wynn Bullock; Steve Crouch; Richard Garrod; Henry Gilpin; Dale Hale; George Sidman; Bob Singhaus; David Smith; Tom Tousey, and Cole Weston.

The following people helped in this book: Rene Anderson; Hilton and Roberta Bialek; Aaron Bleisner; Fred Buskirk; Bob Byers; Dr. Robert Cater; Bill Davis; Setsuko Davis; M. O. Edwards; Steve Farao; Allene Fremier; Kim Gibbons; G.P.E. Communications, Inc.; Meghan Hughes; Cathie Kandler; Maura Krebs; Ling Lau; Ann McLaughlin; Louise Nockideneh; Beth Penney; Jerry Pierson; Gail Racherbaumer; Joe Tanaous, and Tim Taylor.

The drawings by Eldon Dedini are a result of a long collaboration on many projects.

All prints for this book were made on Cachet Fine Art Photographic Papers.

Introduction

Do you want your photographs to be:

- More creative?
- More distinct?
- More striking?
- More meaningful?
- More expressive?
- More passionate?
- More honest to yourself?

■ PURPOSE

If you can answer "yes" to any of the above questions you are ready to learn an approach for making your black-and-white photographs more creative. A creative image is arresting by itself, but black-and-white photography is a dramatic medium. Its sensitive images have a strong, unique impact.

The purpose of this book is to combine drama and creativity as a powerful means of expression and communication. The book's slant is toward a photographer who has a little photographic experience and an interest in photography as a fine art. You will explore a broad array of choices in theme, camera, film, print and presentation. You are an individual whose observation of the world differs from anyone else's. Getting in touch with that individuality in the visual realm allows for a unique style. A creative approach helps you find your individuality. Finding it is hard work; once you

find it, it requires growth and practice, or it will atrophy.

Rather than cover how to operate equipment or use materials, this book covers what to consider when selecting and using equipment, material, and photographic processes. For instructional material on camera operation, darkroom procedures, etc., consult one or more of the recommended books listed in the Additional Resources section at the end of this book.

■ APPROACH

The approach used here is called PhotoStorming. This approach takes

A photographic moment is the celebration of numerous ideas that come together when you are present and available for such an experience. It is a mystical revelation.

the fundamentals of creativity and applies them to the choices, or variables, in photographic expression. The goal is to find new associations and avoid narrow thinking (or getting boxed-in) in solving photographic problems. The purpose of this creative approach is to develop new images tempered with your taste and experience.

The approach is simple. Follow it and give the approach time to assimilate. Then, use what works for you. Your approach should yield success in making unusual associations that express your vision and at the same time enrich your understanding of how and what you see. Plug yourself in and let Photo-Storming start you on the road to using your creative ability in making photographs.

■ SUMMARY

Chapter One discusses the fundamentals of creativity, applies them to photography and provides an example of how PhotoStorming can be used.

Chapters Two through Four present the choices, or variables, from the message to the design; from the camera and the negative to the print and, finally, to the possibilities for presenting your work.

Chapter Five focuses on self-criticism and improving your creative

response, as well as how to avoid creative blocks.

Chapter Six provides exercises that aid in playing with photographic possibilities.

■ How to Use This Book

Photography involves making choices—what to render, the size it should be, from what angle it should be shot, what depth of field should be used, etc. This book will provide you with a basic understanding of the creative potentials of most of these variables—whether camera, lighting, subject, message, or types of presentation.

Study this book and familiarize yourself with the possible variables to use in making photographic decisions. Use the variables to help you make new associations, either by stretching your vision or expanding your taste.

Do some of the exercises to enhance your creative ability. Consider more ideas in a free-flow idea session. Extend that session and stay alert to new possibilities throughout the decision-making process.

Release your inner voice so that you will be free to interpret your photographic expression from your unique and personal perspective, rather than the tastes and influences of others.

This photograph illustrates that individuals can be boxed-in by their vision. You are about to study ways to remove these blocks—to stretch your mind, to expand your taste.

Creativity

In this chapter, you will be exposed to some basic concepts about the creative problem-solving process. In the following three chapters, a descriptive outline of the three other photographic variables will be presented: theme (what you are trying to "say" in your photograph); artistic elements (the basic tools for organizing an image) and the photographic tools (all the elements that you consider, or not, in making a photograph). This book combines all these in a fundamental approach that forms new associations in a photographic print.

■ QUIZ AND ANSWERS

Let's start by taking a three-minute quiz. Pretend you have an assignment to do a portrait of yourself as a photographer. List as many ideas as you can for completing this assignment. You have three minutes. List your answers on a separate sheet of paper. Don't continue reading until you have completed the list.

Stop now and complete the above assignment.

Here are some ideas you might have listed:

❑ Put your image in the camera lens.

❑ Use your camera lens as an eye.

❑ Have a cable release coming from your head with your hand depressing it.

❑ Use your legs as a tripod.

❑ Place only your head on a tripod with a cable release.

❑ Have your camera mounted on a baseball cap.

❑ Place your image on the darkroom easel with a silhouette of you printing under your enlarger.

❑ Make a double image of you photographing yourself in a studio.

❑ Put a button of your image on your camera bag.

❑ Photograph drops of water on a window or car and note your reflections in the droplets.

If you listed more than fifteen ideas, your creative ability is outstanding. What kept you from getting more than fifteen ideas? Or, if you got fifteen or more ideas, why didn't you write more down? You could have changed the camera angle, your position, the symbol you chose so that the viewer would recognize you as a photographer. Try changing the variables of the camera, the darkroom, the studio, the accessories and the symbol.

The wheel below, "Photographic Creative Variables," represents the four broad poles that encompass all the photographic variables to be considered in PhotoStorming. Your objective is to include as many of these areas as possible in conceiving a photograph. You must consid-

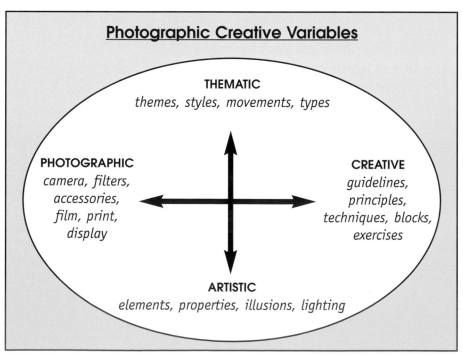

er what the photograph will express in the thematic pole. In the creative pole, you go through the process of generating and evaluating many of the possibilities in both the artistic or organizational poles. In the photographic pole, you consider the possibilities available in the photographic craft: the camera, the film, the print and the presentation.

■ WHAT IS CREATIVITY?

Creativity means finding new associations. Research findings in creativity suggest that creative people have a lot of ideas, and that there are various levels of creativity. Certain activities and techniques help produce more ideas.

A new idea may seem creative to you, to your colleagues and to photographic historians. A novel idea may seem creative just because it is new, but novelty can also result in creating images as a part of your personal growth and your individual way of seeing.

The first step in enhancing your level of creativity is to understand the creative problem-solving process, the idea-finding stage, and the activities you do that will help you produce more ideas. Then, you must understand what blocks you from producing more ideas. And finally, you must understand how to use the photographic variables to produce ideas that are both imaginative and useful.

Setting aside all questions about what creativity is, who is creative, or whether you are creative, consider instead how you can make your photographs more creative. Your photographs will be more creative when you concentrate and use this creative problem-solving process. Your focus, then, should be on becoming more creative rather than on attempting to define who or what is creative. The good news is that creativity can develop over time.

One definition of creativity is the ability to find a new way of solving a problem. In photography, creativity is solving a visual problem in a fresh and distinctive way that expresses or communicates a stronger, more personal or individual meaning. Your intent must be clear and the result must coincide with the intent of the photograph.

■ UNDERSTANDING THE CREATIVE PROBLEM-SOLVING PROCESS

As a photographer, instead of communicating an idea in writing, you are communicating or expressing photographically. Each medium of communication has its own particular challenges.

The first step in making a photograph may be to respond to the subject, then to analyze and determine the theme, the artistic elements and properties, the creative possibilities and the photographic variables. The approach to this step is basic. Don't analyze these components of your photograph too narrowly.

This book, will demonstrate each of these steps and show how you can apply each of them to your individual approach in making a photograph.

Instead of asking, "Am I creative?" ask yourself "Why am I not more creative?" The emphasis in the creative process is on improvement.

You can be more creative by:

□ Avoiding visual blocks that keep you from limiting your creativity.

□ Considering as many ideas as possible before selecting the final photograph.

□ Trying different thought processes or techniques to make creative photographs.

□ Keeping the creative ability alive with exercises.

□ Using the best conditions for idea fluency periods.

□ Writing your artistic statement (see Chapter Five) and self-criticism. An artistic statement is a brief, up-to-date written statement directed at non-artists. It explains why you do your art in general, as well as your artwork in a given exhibit.

There are two recurring themes in the study of the creative process. The first is that a broader choice of possible solutions to a problem generally leads to a more creative solution. That is, it is easier to select a creative solution when you have choices to evaluate. Thus, you must spend more time considering ideas for possible solutions. Secondly, creativity can be cultivated by practice. On the other hand, creativity can atrophy when not used.

> *Imagination is in the mind. Creativity is in the artwork.*

The creative problem-solving process is to creativity what the decision-making process is to business, what the problem-solving method is to mathematics and what the scientific method is to science. Each has similar steps, but the unique characteristic of the creative problem-solving process is the idea-finding stage. This stage is where you separate the listing of ideas from the evaluating of them. The idea stage is where you strive to consider more ideas. The other stages listed are standard to all other processes, like decision-making in business. The creative prob-

lem-solving process is not linear; you can stop during any stage and return to the previous stage.

Generally, you make decisions as you go through a process. In normal decision-making, you weigh and consider given alternatives or possible solutions, but in the creative process you develop new alternatives. You evaluate as many ideas as possible. There are five steps in the creative problem-solving process:

1. Fact-finding
2. Problem-finding
3. Idea-finding
4. Solution-finding
5. Implementation-finding

■ FACT-FINDING

This stage involves finding the facts that determine the visual requirements of the photograph by gathering information about the problem—thoughts, techniques, composition, meaning and so on. The fact-finding stage might start with a fuzzy, unclear feeling about a particular photograph that you want to make.

In this stage you ask questions and get a variety of answers about the who, when, where, why, what, and how of the photograph you think you want to make. You look for the answers to various questions to clarify thoughts about the possible image.

If it is a self-portrait, as suggested in the section at the start of the chapter, you might ask yourself questions like:

❏ Who are you as a photographer? What is your image, your type of work, your approach or style, your likes and dislikes and your sense of humor and taste?

❏ When do you make the photograph? At what time of day or night, season and type of weather?

❏ Where do you make the photograph? In the studio, on location or in a circus spotlight?

❏ Why are you making the photograph? To show people what you do? To create an artistic image? To be clever?

❏ What should you be doing? Holding the camera, in the darkroom, on a tripod, in a photograph in an art gallery coming out of the frame?

You gather all the known facts that might help determine the who, what, when, where, why and how answers. Make a question list and provide answers, no matter how remote they seem. Review them when you are thinking about the problem-finding stage.

■ PROBLEM-FINDING

Define the steps in your attempts to find the problem—questioning, defining, and redefining. "In what way might I photograph...?", "How might I photograph...?" or "How might I change or improve...?" As mentioned before, you may start out with a very fuzzy idea of a photograph. The more you can narrow down a statement of what you want to express or communicate, the easier it is to address ideas that might solve the visual problem. This becomes your problem statement.

The problem statement may also be stated as a question. It is what you are intending to do in making a photograph. The problem statement in the self-portrait quiz you just took is an example. From this list, revise your problem statement. You might list as many ideas as you can for making a self-portrait as a photographer by using reflections of yourself in some object. You might again try narrowing your ideas further. List as many

ideas as you can for making a portrait of yourself as a photographer using photographic gear (camera bag, light meter, lens hoods and so on). You might try narrowing the idea again. Use just the camera and its parts.

You might also try writing a paragraph explaining the who, what, when, where, why and how. List creative types of questions. How might you...? What ways might the photograph be used? What ideas might you produce? What is the real problem?

■ IDEA-FINDING

In idea-finding, you accumulate new ideas. Find as many ideas as possible. The key is that ideas are recorded without judging them as they occur, and that you seek wild ideas. After all, a new idea is often a radical one.

The flow of ideas in the first stage of idea-finding tends to produce familiar ideas. You, or the idea-finding group, purge yourself of what you know. You may enlist a group of friends, colleagues or others to help generate ideas.

As time passes, the flow of ideas normally decreases until a plateau is reached. Then, with an extended effort, newer ideas will come. You strain to continue the process. These ideas tend to be wilder, and they may tend to come in spurts.

If you make an extra effort in this stage, you might want to stop for a while and detach yourself from seeking ideas. Do something else. At this time, more ideas—or perhaps the solution—may come to you. Jot them down for the solution-finding stage.

■ CREATIVE GUIDELINES AND TECHNIQUES

Here's how creative guidelines work. When you are working on the idea-finding stage, the first thing to do is to employ the creative guidelines (see the sidebar) that can help you produce more ideas. You do this by encouraging the flow of ideas without judgment. Do not evaluate any idea as good or bad, relevant or irrelevant. Judging can stop the free association of ideas. The solution-finding stage is for evaluating ideas. Encourage wild ideas by reminding yourself that a creative idea seems wild because it is new, and it may be essentially what you are seeking. If there is a lull, and you think the flow has stopped, you might want to go through the list and see if you can combine any of the ideas. This often coaxes the flow again.

Researchers have observed creative people to find out what mental techniques they use to create. They have found that techniques such as brainstorming furnish a systematic approach designed to facilitate idea finding. Alex Osborn was the first to develop and use this idea in advertising (see sidebar).

Brainstorming in the simplest form is the listing of ideas without criticism; the goal is to seek as many ideas as possible. This book uses the term PhotoStorming to illustrate the same idea. Photo-Storming attempts to use the general research findings on creativity, including all the techniques, and apply them to photography. Photo-Storming uses any means to practice creativity and generate ideas, and applies these creative means to photography using the photographic variables: camera, filters and attachments, accessories, film print and display. The focus is on the generation of ideas and bringing an imaginative idea into reality as a creative photograph. Examples and creative techniques are found in Chapter Five.

■ ALTERNATIVE PRINCIPLES

Another way to make the idea-finding stage productive is using the Alternative Principles. (See the sidebar, next page.) Alternate between thinking up ideas on your own or using a group and perhaps going back to listing ideas on your own. This keeps the ideas flowing. Try using your family or friends as a source of ideas. Consider a research project looking into how visual artists throughout history have explored your specific photographic problem. This is like the fact-finding stage, but you are using other ideas to combine with and improve your own.

You might try thinking up ideas and then judging them as another way of extending the idea-finding stage. First, immerse yourself in the process and then detach yourself. Do a different task. Often the perfect solution transpires after an idea-finding session, when your attention is elsewhere. Again, keep

Creative Guidelines

Use these guidelines in the idea-finding stage.

1. Rule out criticism. Record all ideas without screening them for practicality, duplication or just being "stupid."
2. Encourage free-wheeling. The wilder the ideas, the better. They might "trigger" practical suggestions.
3. Seek a quantity of ideas. It is easier to pare down a long list of ideas than puff up a short list.
4. Combine and improve ideas. Suggest ideas that combine and improve ideas stated during this stage.

Adapted from Alex Osborn, *Applied Imagination*, 3rd Rev. Ed. New York: Creative Educational Foundation, 1993

Selected Creative Techniques

All techniques can be used for both individuals and/or group idea-finding sessions.

1. Brainstorming. Lists ideas in a separate stage that suspends judgment. They are recorded for later evaluation.
2. Reverse brainstorming. Like brainstorming, but lists all things wrong with operation, process, system or product. Then, during the evaluation, suggestions are made to overcome these flaws.
3. Catalog technique. Uses catalogs and other printed information to suggest ideas.
4. Checklisting. Uses checklists to generate ideas.
5. Free association. Uses a symbol, word or sketch related to problem from which to ad-lib.
6. Attribute listing. Uses essential, basic qualities, features or attributes to change or modify ideas systematically.
7. Forced relationships. Analyzes the relationships between two or more objects

Alex Osborn, ibid.

your list of ideas handy so you can add to it. You might also like to change your viewpoint. Look at your problem from different camera angles, as a different person, as someone from another country or culture, as a different psychological type, as an ant or as a zipper.

■ OTHER IDEA-PRODUCING ACTIVITIES

Idea Booklet

Writing a diary or journal means keeping a daily log of activities; an idea booklet is used for thinking about specific photographic ideas. You might sketch in it or list possible photographic ideas. You might record ideas that inspire you, perhaps even record thoughts to consider in writing your artist statement. Many photographers take their idea booklets with them to exhibits and make notes. A photographic idea booklet is just as important to a photographer as sketches and scale models are to architects. So go out and buy a blank book and start keeping a photographic idea booklet.

In your idea booklet (see sidebar), record any ideas you might have. The pages are like worksheets where you can, at any time (like before going to bed) review and add ideas for solutions. This is an exercise book designed to help you to play with visual possibilities. Place it in a central location and jot down ideas for future reference. Use it as a tool to work with ideas. It will help you become more sensitive to the creative process and to a more original expression. The booklet will aid you in completing the creative process, and give new you enthusiasm to make your imaginative ideas a creative reality.

Idea Fluency

Know your idea fluency (see sidebar) and optimum work periods. Sometimes knowing the times and conditions when you are the most productive and most creative can contribute to your success. Do you work better in the morning or evening? What are the circumstances? When are you creative and when do you work successfully? Is it when you are quiet? Is it after a meal? Do you need a work area? Analyze these circumstances and use them to help you improve. When do ideas flow? Before getting up in the morning, in the shower,

while walking, at the start of reading or as a procrastination ploy when doing something you don't want to do? Be alert to your own rhythm.

Artist Statement

Writing an artistic statement is good practice. It explains why you make your art. This will bring up challenging questions to explore. You might also try writing a self-criticism of your work. Look up art criticism and describe, evaluate and interpret it. This will be covered in Chapter 5.

■ SOLUTION-FINDING

You might find a solution by selecting some of the ideas that you feel have creative possibilities. Then, determine the usefulness of each one against appropriate criteria. For example, can it be technically achieved? Is it too costly or time consuming? Is it clear?

You develop the criteria and then test, judge or decide. You may even rank your ideas against the criteria by using numbers. (1-Excellent, 2-Good, 3-Average, 4-Poor and 5-does not pertain.) This method allows you to weigh one possible idea over another. Chances are, with a creative solution, you will go through this stage and the answer will become apparent. You might use the Solution-Finding Worksheet in the back of this chapter or in Chapter Six.

By defining your visual taste, you will find some general criteria that guides your choice. Is it different? Is it exciting? Will the image endure? Does it have magic? Is it expressive? You also might ask yourself about specific criteria for this photograph. Should it be silly, not serious? Should it be whimsical? Should it have strong and simple graphic elements?

■ IMPLEMENTATION-FINDING

Once you have a strong possible solution, make a list for the time when you make the photograph. It should spell out the specific things your are to bring, where, at what time and so on. It should also remind you of what you want from the photograph and other possible photographs you might try. Visualizing all the answers about how the photograph will be made should excite you enough to make the image. (See the Implementation-Finding Worksheet in Chapter Six.) Remember to stay open to changing ideas as they occur—from making the photograph to printing it and displaying it.

■ OVERCOMING CREATIVE BLOCKS

A number of blocks slow or stop you from seeing a problem clearly, stopping or slowing the flow of ideas. Ask yourself which of these blocks (see sidebar) stopped or slowed your flow of ideas when you answered the question in the quiz at the beginning of this chapter.

Perhaps you were distracted by noise while you were reading. Maybe you did not understand the question, were trying to read something else into it, or were thinking about where the question was leading. Sometimes you unconsciously judge ideas and rule them out before you fully consider their potential. A creative answer may take a long time to think up, and a longer time to implement. It is comfortable to have finite answers. Being creative is risky because the answer is untried.

Creative Blocks

A block is anything that hinders the creative process. Blocks can come from seven broad categories.

1. Perceptual. These come from the five senses: smell, touch, taste, hearing and vision.

2. Emotional. These come from feelings, such as joy, sorrow, hate or love.

3. Cultural. These come from ways of living and are transmitted through the generations. They are traits, arts, manners, customs and mores.

4. Imaginative. These are mental images formed from things never experienced. It is lack of access to your imagination, or the inability to use your imagination, that limits you. It is a fear of the subconscious or unconscious thought, or the inability to fantasize.

5. Intellectual. The inability to reason comes from a lack of information, intellectual interests, intellectual tastes, or mental capacity; or the inability to abstract, philosophize, or reason critically.

6. Expressive. The inability to have someone understand the full meaning of your message because words, images, symbols and non-verbal forms of communication are not understood.

7. Environmental. External surroundings affect people. Noise, visual distractions, movement or physical constraints prevent concentration.

Adapted from Robert H. McKim, *Experiences in Visual Thinking* Monterey, CA: Brooks/Cole Publishing, 1972. See Chapter 5 for examples.

■ CREATIVE PRACTICE: AN EXAMPLE

You receive a telephone call from your local arts council asking you to photograph your friend Marsha. The photograph will be displayed at a fund-raising benefit along with other photographs of those to be honored at the event. The project is to be a collaboration between the photographer and the subject.

Your plan is to fact-find, idea-find and come up with a possible photograph to begin a discussion. Next, you will meet with her and discuss the plan. This will mean more fact-finding, a new problem and a new idea-finding session. This will be the major time for collaboration and a chance to clarify criteria. The final meeting will be the photographic session.

Session One

This is the time for you to develop a problem-statement and potential solution. You will go through all the creative problem-solving stages. Your answer at the end is where you will start the discussion with your subject in session two.

Find out more about the subject and your interests. Marsha is the founder and director of a theater. She also teaches drama to children and is a performing artist herself. She is a strong community advocate for local theater and a forceful fund-raiser, a C.E.O. of a children's theater and a theater directed at adult audiences. She is also a playwright, a personal friend and a community figure. She also taught acting to your children. You remember that several years ago you were in London watching *Evita* and recorded an idea from the play in your idea booklet.

The problem statement is, "How can I photograph Marsha?" Next you might continue by listing possible solutions in the idea-finding stage. Remember this is the list of ideas, not the evaluating stage. Here's a list of some ideas you might have come up with:

□ A sequence of photographs showing her in various roles.

□ Use color print and transparency film.

□ Use black-and-white film.

□ Use Polaroid transfer.

□ Make a multiple exposure.

□ Do a timed sequence.

□ Photograph her during class session with children surrounding her and parents as onlookers.

□ Present her in a teaching pose.

□ Make her look like an actress in a classroom setting.

□ Dress her in costume.

□ Dress children in costume.

□ Children in dress rehearsal, and your subject could be dressed in business attire to show her role as director.

□ Use the idea from *Evita*: light Marsha with three spots, each casting a different shadow: one as director of theater; another as actress and another training children. Each shadow represents a different role of your subject.

Sometimes talking to someone and giving that person a lot of ideas is overwhelming. Because of this, you decide to start your discussion with a solution: the solution-finding stage.

What are the criteria for judging the idea, or, what is a temporary solution? The idea needs to be agreeable to the subject. It needs to be bold—an unusual approach, yet one that can be completed within the deadline, at low cost and within a mutually agreed schedule. After evaluating the list of ideas, the idea that excites you most and seems to fit the above criteria is the lighting technique from *Evita*.

In the implementation-finding stage, make a model of the portrait by using three blackened cardboard impressions of her shadow to show her three roles: teacher, director and actress. Armed with these ideas, you are now ready for session two—collaboration with Marsha.

Session Two

You meet with Marsha and discover she is waiting to discuss your ideas. She is willing to listen to your *Evita* idea, but she has concerns about it.

She prefers to start the discussion with a specific idea and then reacts to that idea. The main concern is that she will not be able to schedule enough time for such an involved portrait. You learn that the portrait actually needs to be done over the weekend during one of her classroom sessions. That sheds a different light on things, and you sit down for an idea-finding session.

You toss around ideas and come up with doing a simple, straightforward portrait of Marsha sitting on a stool and instructing her students.

You both conclude that you will think about doing a straightforward portrait and not an involved sequence or something that could require hours. A date is made to meet again on the weekend for the portrait.

Session Three

You decide to go back to your studio to do another idea session. Some more ideas develop:

□ A simple portrait without using the sequence of images as in *Evita*.

☐ Use flash.

☐ Put some movement in the picture.

☐ Have children surround Marsha in motion, maybe circling her.

☐ Marsha holds a long pose. Also use color.

You make a clear listing of specific criteria for this photograph and a general list of things you look for in making a photograph. Here is where you consider as many activities as possible: message, camera, film, printing and display.

After completing the "Idea-Finding Worksheet," using the "Solution-Finding Worksheet" and "Implementation-finding Worksheet" (see blank forms in Chapter Six) will help you be fully prepared for the photography session. On the following two pages, you'll find the completed "Solution-Finding Work-sheet" and "Implementation-finding Work-sheet" for the session with Marsha. Keep in mind that these are filled out specifically for

this example—the criteria and implementation will be different for almost every session.

Serendipity might change any part of the solution.

Of course, you must also be open to things occurring differently during the photographic session than you had planned. This is where serendipity might change any part of the solution.

Flash lighting was used during a one second exposure at F/8. Children were directed to move around subject.

SOLUTION-FINDING WORKSHEET

List all the ideas from the "Idea-Finding Worksheet" that have possibilities. Next, fill out the specific criteria for this photograph (or series) and the general criteria. You can rank the ideas using numbers against the criteria. (1-Excellent, 2-Good, 3-Average, 4-Poor and 5-does not pertain.) This method usually weighs one alternative over the other. Chances are with a creative solution you will go through this worksheet and the answer will present itself. These criteria then act as a checklist.

SPECIFIC CRITERIA: **GENERAL CRITERIA:**

IDEAS:	agreement with subject	low cost	short time	director/teacher	technical quality	accessibility	open-ended	clarity	
1. Evita idea	3	4	5	1		1	2	2	2
2. simple portrait with movement	2	1	1	1		1	1	2	2
3.									
4.									
5.									
6.									
7.									
8.									
9.									
10.									
11.									
12.									
13.									
14.									

The specific criteria for this photograph were:

• Agreement with the subject because it was collaborative
• Low cost
• Short amount of time to make photograph
• Subject should look like a director and teacher of children

IMPLEMENTATION-FINDING WORKSHEET

Start here when you already have a strong idea. Start with the "Visual Problem and Idea-finding Worksheet" (see Chapter Six) first if you have a general idea but no strong image.

Title: Marsha

Color, B&W, or Other: Color, B&W

Shooting Date: March 10

Weather: (indoor)

Shooting Time: 10:30 am at theater

Location: theater

Circumstances--Idea Date: _____

Place: _____

Sketch/Work Print/Instant Print:

(Sketch
of
Marsha)

Description (effect, expression, light, graphic impact, emotion, content, etc.):

Marsha appearing very regal and drama students (children) out of focus running around her. Try Marsha both in profile and front-view (double exposure). Marsha sitting on stool at a height that doesn't block children circling her. Platform needed in back of her in order to ensure that the children are visible.

Technical (print quality, size, lighting, film, filter, possible problems, etc.):

Bring assistant to help direct children.

Props and supplies:

Tungsten lighting kit. Films (100 ISO color transparency and black & white). Stool. Extension cord.

What other photographs might be made at this time?

Misc. (permits, releases, clearances):

Try various positions for Marsha.

②

Theme and Design

Just as literature attempts to express and communicate, so does photography. In literature, the structure is grammar, syntax and the connotation and denotation of words. In photography, the structure is the elements and properties of design and the meanings of images. What photographs can express or communicate and how they are designed is the subject of this chapter.

> *The theme conveys the photographer's meaning.*

■ THEME, SUBJECT AND MESSAGE

The theme is the broad meaning of the photograph intended by the photographer. Broad themes may range from conflicts—of love or of hate—to narrative. Theme can also be viewed as a photographer's interest in, or concerns about, time periods, movements, or certain artistic styles.

Categories, types, or subjects of photographs can also illustrate theme. For example, the F/64 Group movement, a major photographic movement that is a strong component of modernist theory, is concerned with rendering the subject as purely as the eye sees it. This aesthetically evaluative movement also strives for the highest photographic technical possibility: lumi-

nescence in the shadow, full scale print, sharpness, detail, and so on. The movement has strong proponents with photographers such as Ansel Adams, Paul Strand and Alfred Stieglitz.

The subject is the thing being photographed. Subjects may be portraits; natural, social, or urban landscapes; war; nudes; still life; fashion or street scenes. After a photographer has decided on a subject, the theme conveys his or her meaning, or message, which differentiates this photographer's intent from all other photographs of similar subjects.

The message is what the viewer derives from the photograph. For example, the subject of a photograph may be "reading," and the photographer's theme may be that reading has its distractions. The theme must apply to people outside the photograph and comment on the human condition.

There may be more than one theme, or there may be no theme. In complex photographs, it may be hard to determine the subject and theme with certainty. If the theme the photographer intended to convey is not the message the viewer receives, the photographer has failed in his or her intention, although the photograph may still be strong and have a life of its own.

Themes can deal with general areas such as the individual, humankind, nature, God, or the preternatural, the abnormal or the supernatural. When deciding on a theme, ask these questions: What is the subject or what is the work about? What does the work say about the subject? In what direct or indirect ways does the work communicate its theme? What image of humankind emerges from the work? Does the photographer portray a particular society or social scheme as life-enhancing or as life-destroying? What control over their lives do the characters have? What are the moral conflicts in the work? What is the physical setting? What is the social environment of the characters? What are the manners, customs and moral values that govern the character's society?

The following are some broad possible photographic themes. They may overlap.

Achievement is when a subject is photographed as being successful or at the moment of truth. An example might be the sculptor next to his work.

Beauty is the expression of the idealized form of beauty.

Shakespeare wrote, "There is nothing either good or bad but thinking makes it so." This quote could be paraphrased as "There is

This is the sculptor, Alex Weygers, and his work—an example of a photograph showing achievement.

(Above) This photograph of a waterfall in Maine depicts natural beauty. (Opposite) This was a photograph from a portfolio on reading (and, here, its distractions) and is an example of humor.

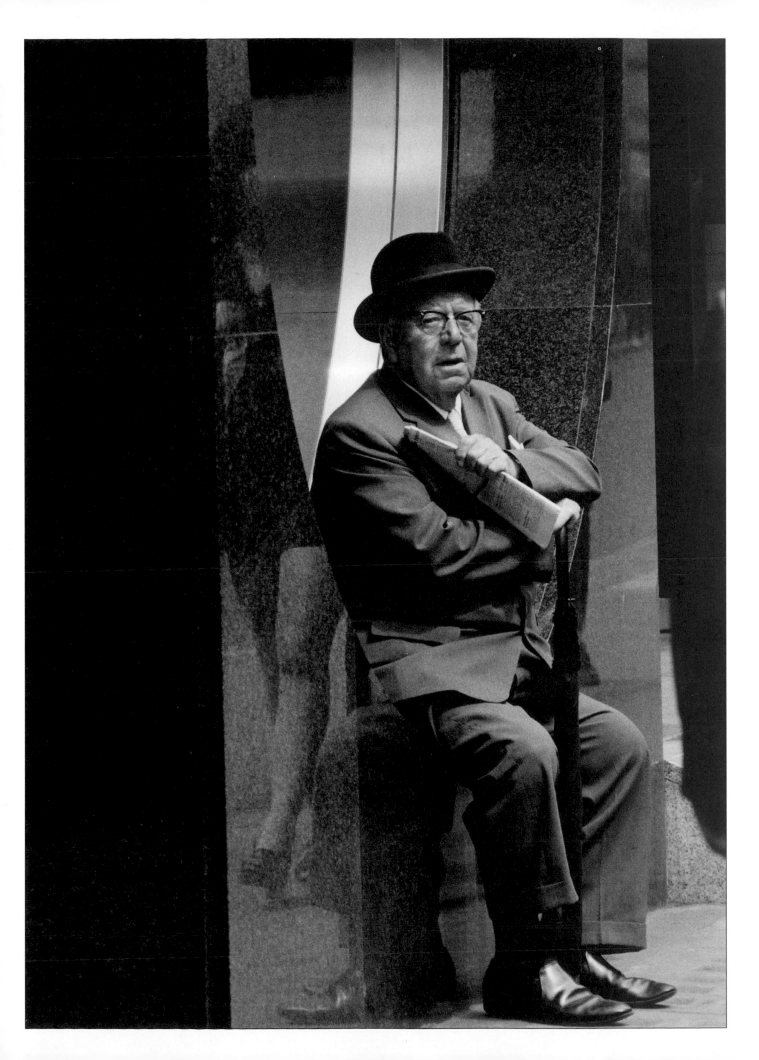

nothing either beautiful or ugly but thinking makes it so." Beauty is a matter of taste and sensitivity. The sense of beauty is different at different times, in different places, and for different cultures. Ultimately, beauty is indeed "in the eye of the beholder," in this case the photographer.

Because an idealized form depends on a given time, culture, and point of view, the photographer needs to know his or her criteria and make them clear to the viewer. What is important is to get the viewer to see the beauty you see.

Concern for others is the expression of altruism or compassion. The purpose may be to document the fundamental social issues of race relations, poverty, population growth, under-served members of society, immigrants, or other issues, with an eye toward inform-

ing others and instilling tolerance, acceptance, respect, and even love among viewers of the photographs. Photographs are not necessarily meant to change laws, but they can make strong statements about social injustices.

Conflict is a clash or disagreement. It may be a physical struggle or mental incompatibility. There are several basic conflicts: man against himself, others, nature, society, God, the preternatural, the abnormal or the supernatural.

Emotions are the affective state of being—such as joy, sorrow, fear, love, or sentimentality—as distinguished from the rational state. Photography is the spontaneous overflow of powerful feelings.

The human condition is the expression of what is common in humanity, be it good or bad. Photographs of the human condi-

tion express the noble qualities of the human being to inspire, and in this case, look at what is right with the world. They might document the dignity of the worker, the beauty of age or the human spirit over adversity. They might also document man's inhumanity to man to show what is wrong with the world.

Humor, wit or satire show a subject's funny or amusing quality.

Humor consists principally of the recognition and expression of incongruities or peculiarities present in a situation or character. Artists frequently use it to illustrate some fundamental absurdity in human nature or conduct, and it is generally thought of as more kindly than wit. Humor implies a genuine sense of fun and the comic impersonal or gently personal.

Wit is a purely intellectual manifestation of cleverness and quickness of comprehension in discovering analogies between dissimilar things. These analogies are expressed in brief, diverting, often sharp and often unflattering observations. Humor and wit are contrasting terms that agree in referring to an ability to perceive and express a sense of the clever or amusing.

Satire is the use of irony, sarcasm, ridicule or the like, in exposing, denouncing or deriding vice or folly. Satire generally emphasizes the weakness more than the weak person, and it usually implies moral judgment and corrective purpose. As forms of humor, lampooning also refers to ridiculing vices or follies.

Irony achieves the opposite of the original intention. The essential feature of irony is the indirect presentation of a contradiction between an action or expression and the

The awards ceremony for Santa's Helpers shows concern for others.

The younger photographer kneels in admiration in front of the older photographer, an example of narrative. This photograph was taken on a theater stage with existing light which happened to be a cathedral window design from a gobo light.

context in which it occurs. Irony differs from sarcasm in greater subtlety and wit. In sarcasm, ridicule or mockery are used harshly, often crudely and contemptuously, for destructive purposes.

You might like to use the visual pun. This is where the subject is nearly like another in appearance but different in meaning. Another form of visual humor is the parody, which is to imitate something in a ridiculous way.

Narrative is telling a story or some event, usually presented as a series of photographs. These may be true or fictional allegories, with an emphasis on action.

Newness for newness' sake is when the content of a photograph forms new associations for no reason other than to be different.

Nostalgia is evoking concern for the past, especially when it is idealized or romanticized. It is often a return to the better times, family or friends and thoughts. Nostalgia appeals to memories of the past that are usually comfortable and warm. Nostalgic photographs may depict heroic or marvelous achievements and experiences, colorful events or scenes of chivalrous devotion. They often excite the imagination.

People in action is capturing people spontaneously and showing the beauty of movement. This type of photography is frequently done in sports and dance.

Photo as art object emphasizes the design elements and properties. The form, line or tone is appealing unto itself. This type of photograph is a beauty of design rather than expression. Stressing the beauty of light and dark is another element of this type of work.

Photo as poem is the subject transmuted to symbol, metaphor, analogy or even a direct appeal to the emotions.

Scenes are views of nature showing the beauty of the landscape. Italian painters were particularly interested in designing a pictorial plane to manage eye movement. They worked with illusion of depth to draw your eye toward the background along an interesting path.

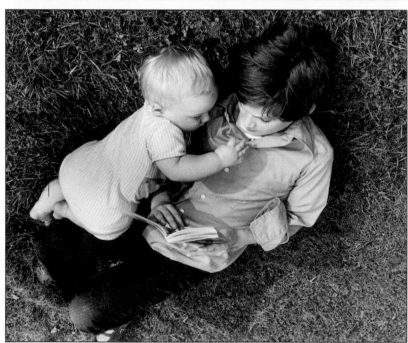

(Top, Left) This photograph of a kitchen table conveys a sense of nostalgia. (Top, Right) For more on this example of photography of a scene, see the sidebar on page 25. (Bottom, Left) This photograph of Sissinghurst stairs depicts surrealism. (Bottom, Right)This photograph of two boys depicts sympathy.

Various elements must be consider ed when photographing a scene. (See sidebar, opposite page.)

Surrealism shows what takes place in the subconscious, often having no conventional order. This form of photography can also be dreamlike.

Symbolism is where the subject in the photograph represents some-thing else. Natural symbols repre-sent nature. Mood symbols stand for personifications or abstractions of ideas. Idea symbols suggest worldly customs, religions or world-views. Spiritual symbols represent the spirit in calm or vigilance, or a dynamic spirit. Melodic symbols can be high and low or strong and weak, gradually reaching a climax.

Sympathy is sharing of anoth-er's sorrows or trouble.

There are broad or specific themes that photography expresses. Some of these overlap and some are clearly different. Add some of your own to the above list. Consider sub-themes. Analyze the themes you generally express. Try working in a different theme.

Traditional Landscape Elements

1. Photographic surface. This is the enclosed two-dimensional surface of the photograph. (Figure 1)

2. Foreground establishes scale. The viewer measures the space of the picture plane and gives the eye something to look at and look past. (Figure 2)

3. Lower foreground pulls eye down (eye drop, ledge, or stage). (Figure 3) The foreground forces the eye to drop out into the picture plane.

4. Stage wings bracket foreground. They are the dark masses between the inside visual frame and the central frame. (Figure 4)

5. Visual frame covers four corners. It stabilizes the picture by giving deep shadow to corners. (Figure 5)

6. Diagonal leads eye to distance. The eye enters the picture at left, and heavy lateral right acts as counter balance. (Figure 6)

7. Right angles enhance illusion of space and stabilize picture. They frame the receding lateral boundaries. (Figure 7)

8. Foreground, middle ground and background give illusion of depth. Parallel spatial structure helps produce a linear order and divided space. (Figure 8)

Adapted from Chip Sullivan, *Drawing the Landscape*, New York: Van Nostrand Reinhold, 1995, pp. 168-169.

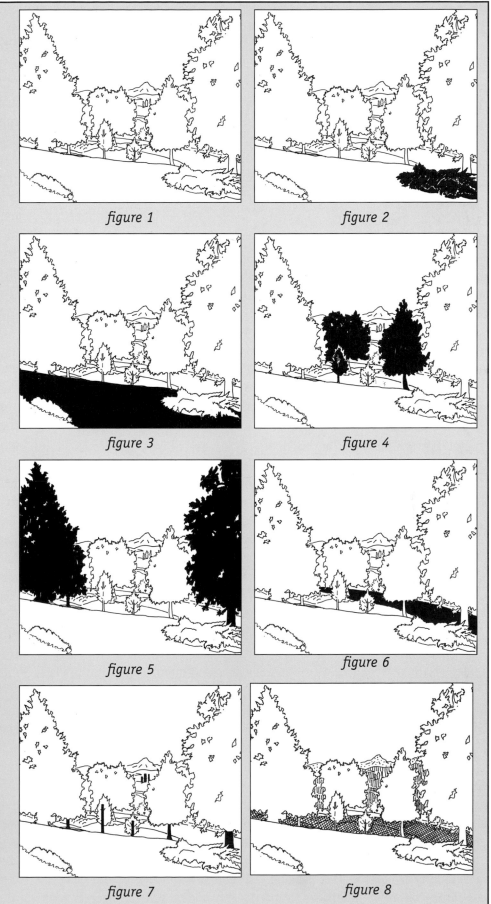

figure 1

figure 2

figure 3

figure 4

figure 5

figure 6

figure 7

figure 8

■ ART STYLES, MOVEMENTS, AND TYPES OF PHOTOGRAPHS

PhotoStorming means considering different ways to change or improve a photographic expression. One way to change or improve an expression is to look at what other photographers have done. It is a possible source of ideas for you to consider. Try exploring some of the art styles, photographic movements, and categories or types of photographs. Studying major art styles might suggest ideas for changing your statement, way of seeing or dealing with the subject. References to major art styles are included in the sidebar to help you explore them and to suggest study in more depth.

Art style is a particular way in which the forms that make up any style are chosen and fit together. These "periods" need to be learned if you are to understand how artists deal with subject, symbolism and implication. How else are you to judge whether your work is derivative? How else are you to know your influences? Art styles can give you a general context, while photographic movements give you concerns relevant to photography. Both share these common concerns: what does the artwork say, and how does artwork say it?

The sidebar entitled "Art Styles" offers an overview of many popular and historical movements, and will help you to understand your own purpose and intent. Understanding these styles will give you a sounding board for your own ideas and thoughts. It will also stimulate more ideas for possible solutions.

Like artistic styles, photographic movements group together similar concerns which photographers share. These concerns bind them toward a general common goal. Movements help us analyze and compare the relationships of design and the progressive development of ideas toward a particular conclusion. Movements, or categories of photographs also give you an opportunity to interpret photographs, not just by subject matter or form, but by comparison.

Distinctive photographers provide us with personal approaches. Their styles depend on the individual artist's personality and the context of time and place. The photographers who are discussed below were selected for having a clear and decidedly personal approach to their subject matter. They also worked long enough to establish a rich body of work that is accessible to public view.

■ SELECTED PHOTOGRAPHIC MOVEMENTS

The Allegorical (1850s to late 1870s). Photography followed painters in using illustrative and storytelling themes. Subjects ranged from portraits to romantic costumed and posed scenes. Painted backdrops were created by using multiple negatives to make the composite print. Often the subject was a sentimental view of daily life. Henry Peach Robinson led the High Art movement, the aim of which was to interpret beauty using any manipulative device available. His goal was "to elevate the subject, to avoid awkward forms and to correct the un-picturesque."

Naturalism (1880s). This movement was led by Peter Henry Emerson and worked against the Allegorical movement. His goal was to render the subject directly with-out manipulating the print. The use of simple equipment, free composition and slightly out-of-focus backgrounds characterizes the style.

The Pictorialists (1890s). This was an international movement interested in "art for art's sake." It used competitive juries and camera clubs to promote itself. Photographers in this movement combined other media with photography to make the photography look more like French Impressionist painting. They used many devices to achieve the mood, light and atmosphere—like soft focus, diffused light and grain. Landscapes were misty, cityscapes were soft and details were suppressed. Gum bichromate, charcoal drawing, mezzotint and many other media were used to create images that looked like paintings. Alfred Stieglitz was a strong leader.

The Futurist Movement (1900s). Changes in science, technology, society and art redefined the meaning of art. Movements like Expressionism, Cubism, Dadaism and Surrealism influenced photography. László Moholy-Nagy, in 1922, experimented with photograms, photomontages, the Sabattier effect, unusual angles, optical distortions and multiple exposure to create a more complex imagery. Man Ray worked with absurdities of subject matter and contradictions in the Dadaism movement.

Straight Photography (popular 1930s to 1950s). This movement started in about 1917 when Stieglitz published Paul Strand's work. Stieglitz believed photography was the best medium for objectivity. Photographs were direct and unmanipulated. Stieglitz felt that a photograph was an external or visu-

Art Styles

1. Classical. The art of ancient Greece and Rome (500BC-480AD), noted for its rationality, simplicity, balance, proportion, intellectuality and controlled emotions.

2. Byzantine. The art of the Eastern Empire after the fall of Rome, noted for its formality and rich use of colors.

3. Romanesque. The art, especially architecture, of Western Europe from 1050 to 1200. Buildings feature round arches and solid, heavy construction in imitation of Roman styles.

4. Gothic. The art of late Medieval Europe. The architecture features pointed arches and light, graceful construction; the painting strives for realism and detail.

5. Renaissance. The cultural milieu of Western Europe from the 14th through 17th centuries. Artists pursue the late Gothic interest in realism and master such problems as depth, perspective and realistic lighting effects.

6. Baroque. The highly complex art of Europe from about 1600 to 1750, noted for the intricacy and lushness of its creations. Rococo art carries this luxuriousness to an even greater degree.

7. Genre Painting. Art depicting everyday scenes for its-own-sake. Style dates back to the 1500s.

8. Neo-classical. Art concerned with formality in the imitation of the classical arts.

9. Romantic. Art dedicated to depicting real emotions and character, favoring intuitional approaches for emotional effects.

10. Expressionism. Art concerned with transferring the artists' emotions to the creation, often depicted by a distortion in from or color. Some French Expressionists use vivid colors and strive for a look of spontaneity.

11. Cubism. Presenting multiple viewpoints in a single design. Picasso and Braque invented the style.

12. Dadaism. Anti-artistic movement that champions absurdity against conventions in all aspects of culture. It arose in protest to the madness of WWI.

13. Surrealism. Art that seeks to express the individual subconscious mind in a way that reaches the unconsciousness of the viewer.

14. Art Nouveau. Art that emphasizes organic forms, often with an erotic effect.

15. Abstract. Art in which the subject is no longer recognizable outside the design area.

16. Abstract Expressionism. Painting in which the paint is applied in an apparently random manner to reveal the artist's inner world.

17. Minimalism. Artwork depends on first impression by reducing properties to the most essential. It is an object rather than a representation of an object.

18. Pop Art. Fine art that depends upon industrial media techniques and popular culture for inspiration. It rejects traditional materials and uses appropriation

19. Folk Art. Art created by untrained artists, or in imitation of this naive style by trained artists.

20. Postmodern. Art-making and criticism exploring both composition and content in context to aesthetics and its role in society. It uses appropriation and reappropriation, pastiche, repetition and commodification in challenging subjectivity and authorship. Themes are deconstructive criticism, feminism, Marxism, semiotics and psychoanalysis.

Adapted from E.H. Gombrich, *The Story of Art*, London: Phaidon Press Ltd., 1995.

al metaphor, as well as an inner feeling or its equivalent. The real object functioned as a metaphor for an inner feeling. Images were previsualized from concept to final print. Alfred Stieglitz, Ansel Adams and Minor White were influential.

Regional Styles (1950s). The west coast became the West Coast School of Straight Photography (with Ansel Adams and Minor White), while the east coast became the center for social documentation, with groups like the Photo League. Also important was Robert Frank's subject matter and style. Later Diane Arbus, Lee Friedlander and Garry Winogrand developed personal, and often grotesque social images.

Cross-Fertilization (1960s to Present). Photographers started using old processes and mixed media. (This style resurfaced in the 1990s.) Constructions, appropriation and the use of commercial printing of photographs became popular. Personal and social postmodern concerns dominated photography. The early 1990s saw the application of digital imaging begin to enhance and expand photographic image-making.

■ CURRENT THEORIES OF ART

The question, "What is art?" should also be considered in your approach. Some of the most popular current theories defining art are discussed here.

Realism suggests that the purpose of photography is to render the true object. Reality is the strength of the medium. A photograph should portray the subject accurately in its natural state, without any manipulation or alteration. The F/64 Group embodies this approach. Alteration is frowned upon, as is a "painterly" quality, soft focus, or a shallow depth of field. This theory takes into account that the eye "sees" differently from the camera, so the accurate image is really an illusion.

Expressionism suggests that more of the artist's expression should be in the photograph. This theory emphasizes the photographer rather than the realism of the world. The pictorialism movement, one of the movements that embraces expressionism, uses soft-focus, allegories, collages and other types of special techniques.

Formalism stresses "art for art's sake" and uses abstract form rather than relying on the physical or social world. It should be judged on form rather than on its religious, historical or social content, all of which are "non-art" concerns. This theory has its roots in the 1930s.

Instrumentalism stresses "art for life's sake"—art is a means of expressing social, moral and economic issues.

Form is important to the first three theories of art. The expressionists use form as the key subject. The realists use it to emphasize the beauty of nature. The formalists support form within abstraction. The instrumentalists use form only as a significant element in social concerns.

There are other theories such as craftsmanship, originality and good composition.

■ DESIGN

Tradition gives us the do's, don'ts and meanings of visual symbols, but that does not mean you can't change tradition. Consider both traditional and untraditional points of view when using all the variables in your photographic scene: theme, design, camera, film, print and presentation.

There are three basic design structure components: line, volume, and value.

Line. The curved line prevails in nature; the straight line is created by people. Different types of lines suggest different psychological meanings. Some of these include: straight (direct and rational); vertical (static and strength); horizontal (stable and calm); oblique (indirect); irregular (character and age); contrasting; (grouping visual volume); diagonal (motion); curved (slow, meandering), and broken, implied or zigzag (speedy motion).

Volume in two-dimensional art gives the illusion of shape. It is

Types of Photographs

The following are general categories of photographs that suggest overall purpose.

1. Descriptive. Attempting to accurately record subject matter, for example, scientific and passport photos.

2. Explanatory. These help the viewer understand the workings of something. Eadweard Muybridge, Harold Edgerton, Edward Curtis, Bill Owens, Mary Ellen Marks, Larry Clark and most press photographers fall into this category.

3. Interpretive. Explain how things occurred via a photographer's personal and subjective interpretation. Minor White, Gertude Käsebier, Ralph Eugene Meatyard, Jerry Uelsmann, Les Krims, Sally Mann, Duane Michals, Ralph Gibson, Joel-Peter Witkin, and Richard Avedon are examples of interpretive photographers.

4. Ethically Evaluative. Show how things ought, or ought not, to be, as in the work of Walker Evans, Dorothea Lange, Eugene Richards, Mary Ellen Marks, Jacob Riis, FSA, Robert Heinecken and W. Eugene Smith.

5. Aesthetically Evaluative. Worthy of aesthetic observation and contemplation, usually nudes, landscapes or still lifes. Examples can be found in the works of Robert Mapplethorpe, Bill Brandt, Edward Weston, Brett Weston, Wynn Bullock, Ansel Adams, Paul Caponigro and Imogene Cunningham

6. Theoretical. Comment on issues about art and art-making. Photographers in this category are Cindy Sherman, Richard Prince, Vikky Alexander, Sherrie Levine, Thomas Barrow and Ken Josephson

Adapted from Terry Barrett, *Criticizing Photographs*, Menlo Park, CA: Mayfield Pub., 2000.

Selected Individual Photographers with a Distinctive Style

These photographers have distinctive approaches and their work is readily available in books for easy reference. You can also check the Internet for samples of photographers' work.

Ansel Adams
Ansel Adams. *Examples: The Making of 40 Photographs*. New York: New York Graphic Society Books, 1983.

Richard Avedon
Richard Avedon and Laura Wilson. *In the American West*. New York: Harry N. Abrams, 1985.

Brassai (Gyula Halasz)
Anne Wilkes Tucker, Richard Howard and Avis Berman. *Brassai: The Eye of Paris*. New York: Harry N. Abrams, 1999.

Robert Capa
Robert Capa. *Portfolio Robert Capa*. Te Neus, 1999.

Paul Caponigro
Paul Caponigro. *The Wise Silence*. New York: New York Graphic Society Books, 1983.

Bill Brandt
Bill Brandt. *Nudes*. London: G. Fraser, 1980.

Henri Cartier-Bresson
Henri Cartier-Bresson. *The World of Henri Cartier-Bresson*. New York: Viking, 1968.

Robert Doisneau
Peter Hamilton. *Robert Doisneau: A Photographer's Life*. New York: Abbeville Press, 1995.

William Eggleston
Harold Edgerton. *Moments of Vision*. Cambridge, MA: MIT Press, 1979.

Walker Evans
Judith Keller, Walker Evans, and John Harris (ed.). *Walker Evans: The Getty Museum Collection*. J.P. Getty Museum, 1995.

Robert Frank
Robert Frank. *The Americans*. New York: Grove Press, 1959.

Lewis Hine
Naomi Rosenblum, Lewis Hine, and Alan Trachtenberg. *America and Lewis Hine: Photographs 1904-1940* (Exhibition). Aperture, 1997.

David Hockney
David Hockney and Alain Sayag. *David Hockney Photographs*. Petersburg Press, 1982.

Michael Kenna
Michael Kenna. *A Twenty Year Retrospective*. Santa Monica, CA: Ram Publications, 1996.

André Kertész
Pierre Borham, ed. *André Kertész: His Life and Work*. Boston, MA: Bulfinch Press, 1994.

Barbara Kruger
Barbara Kruger. *Remote Control: Power, Cultures, and the World of Appearance*. Cambridge, MA: MIT Press, 1993.

Dorothea Lange
Elizabeth Partridge, ed. *Dorothea Lange: A Visual Life*. Smithsonian Institution Press, 1994.

Jacques Henri Lartigue
Vicki Goldberg and Jacques Henri Lartigue. *Jacques Henri Lartigue, Photographer*. Bulfinch, 1998.

Annie Leibovitz
Annie Leibovitz. *Annie Leibovitz: Photographs 1970-1990*. New York: Harper Collins, 1991.

Sally Mann
Sally Mann. *Immediate Family*. New York: Aperture, 1992.

Mary Ellen Mark
Mary Ellen. *Passport*. New York: Lustrum, 1974.

Duane Michaels
Duane Michals. *Real Dreams*. Danbury, NH: Addison House, 1976.

László Moholy-Nagy
Louis Kaplan. *László Moholy-Nagy: Biographical Writing*. Duke Univ. Press, 1995.

Robert Mapplethorpe
Robert Mapplethorpe. *Mapplethorpe*. New York: Random House, 1992.

Eadweard Muybridge
Eadweard Muybridge and R. Taft. *The Human Figure in Motion*. Dover Pub., 1989.

Helmut Newton
Scalo Verlag, June Newton and Walter Keller, ed. *Pages from the Glossies & Facsimiles* 1956-1998. 1999.

Bill Owens
Bill Owens. *Suburbia*. San Francisco: Straight Arrow Books, 1973.

Olivia Parker
Olivia Parker. *Weighing the Planets*. New York: National Graphics Society, 1987.

Cindy Sherman
Cindy Sherman and Elizabeth Smith. *Retrospective*. Thames and Hudson, 1997.

Man Ray
J.P. Getty Museum Publications. *In Focus: Man Ray*. J.P. Getty Museum, 1999.

Jacob Riis
Jacob A. Riis and David Leviatin, ed. *How the Other Half Lies*. St Martins Press, 1996.

Sebastião Salgado
Sebastião Salgado. *Workers: An Archeology of the Industrial Age*. New York: Aperture, 1993.

August Sander
Gunther Sanders, Ulrich Keller, and Linda Keller, et al. *Citizens of the Twentieth Century: Portrait Photographs, 1892-1952*. MIT Press

W. Eugene Smith
W. Eugene Smith and John T. Hil, ed. *W. Eugene Smith: Photographs 1934-1975*. Henry Abrams, 1998.

Edward Steichen
Joel Smith. *Edward Steichen*. Princeton: Princeton University Press, 1999.

Alfred Stieglitz
Alfred Stieglitz. *Alfred Stieglitz, Photographs and Writings*. Bulfinch Press, 1999.

Paul Strand
Paul Strand, Catherine Duncan, Ute Eskildsen and Cesare Zavallini. *Paul Strand: The World on My Doorstep, the Years 1950 to 1979*. Aperture, 1994.

Jerry Uelsmann
Jerry Uelsmann. *Jerry N. Uelsmann*. New York: Aperture, 1973.

Brett Weston
Carol Williams. *Master Photographer*. Photography West Graphics, 1989.

Edward Weston
Terrance Pitts and Manfred Heiting, ed. *Edward Weston: 1886-1958*. Taschen, 1999.

Minor White
Minor White. *Mirrors Messages Manifestations*. New York: Aperture, 1969.

Joel-Peter Witkin
Joel-Peter Witkin. *Joel-Peter Witkin*. San Francisco: Museum of Modern Art, 1985.

Adapted from Harald Mante, *Camera Composition*, New York: Focal Press Limited, 1971.

created when a line is given thickness or encloses an area, creating space. Positive space is space within a shape, and negative space surrounds the shape.

Value is the relationship of lightness and darkness in black-and-white photography. On photographic paper, value is represented by tone (darks) and tint (lights). There are many variations and combinations of each element.

"Camera Composition" (sidebar) presents a summary of possible combinations to consider when composing your photograph.

■ ELEMENTS

An element is an ingredient that must be present in a photograph or the photograph could not exist. For instance, a photograph that has no size cannot exist. The necessary elements are:

□ **Surface** is the outermost layer of the substance or material on which the picture is made or shown.

□ **Masses** are the spots of which the image and the entire picture are put together. Connecting spots with ideas makes all images. The picture-plan itself is a spot or mass.

□ **The subject** is the idea, emotion, object or person represented by the image, and by the entire picture. This is the most important element, because pictures are made for the express purpose of presenting the subject or the idea.

□ **Picture limits** are like boundaries, or frames, of the photograph.

□ **The number** is the countable quantity of the images.

□ **Size** is the measurable magnitude of images, also called proportion.

□ **Position** is the place or location of the images in relation to each other and in relation to the limits of the picture-plan.

□ **Pattern** is the outer configuration of the masses. It has a shape that has no meaning or significance until it is invested with an idea. This meaningless volume is called pattern.

□ **Volume** is changed from pattern when an idea is given to the mass. Volume may not be present in an abstract pattern of design, abstract ornamentation or decoration. Shape is three-dimensional. Volume can be silhouette, contour or edge volume. It may vary both in number and dominance.

□ **Line** is the alignment in a photograph of the images with each other along their axes. It may be a straight line, a circle, triangle, square, rectangle, oblique, or other shape. An image has many axes along which it can be lined up with other images. Outline is identical with the shape or pattern.

□ **Tone** is the relative darkness or lightness of the images in relation to each other and in relation to black and white.

□ **Edge** refers to the border areas of masses and images.

> *An element is an ingredi that must be present.*

□ **Rhythm** is the repetition of masses and images. The order, or rhythm, creates the mood.

□ **Composition** is the arrangement of images within definite limits to express emotions and ideas.

■ PROPERTIES

Properties are the ingredients that may be present or absent in a photograph, but whose absence would not prevent the existence of the photograph. For instance, a photograph can exist that has no illusion of depth or balance.

Examine the elements and properties which make up each of these photographs.

☐ **Completeness of the image.** Images may represent the idea or emotion entrusted to them completely, incompletely or over-completely.

☐ **Completeness of the photograph** means the photograph is complete because all the images necessary to represent a given idea are visibly present.

☐ **Texture** is the physical quality of the substance or material of which the subject is made.

☐ **Depth** is the illusion of a third dimension provided by distance, shape or thickness of the subject on a two-dimensional or flat surface.

☐ **Motion** is the illusion of action or movement in a still image.

☐ **Balance** is the impression of steadiness (or the absence of lopsidedness) in the picture. The photograph may be symmetrical, asymmetrical or juxtaposed, as to size, direction or perspective.

☐ **Unity** is the impression of both mental and graphic oneness in a picture.

☐ **Clarity** is the understandability that can be called mental clarity. The carrying power, or easy visibility, is called the graphic clarity.

☐ **Dominance** is the preference of one image or group of images over other images.

☐ **Duration** is the representation of given lengths of time.

☐ **Harmony** is when the viewer feels that the images in a photograph fit together so well that he cannot find anything wrong with the composition.

☐ **Perspective** and space is the way the eye sees the relative position of objects and their distance in a photograph. They may be compressed (like from a long lens) or expanded (like with a wide-angle lens). There may be negative space, the space surrounding the figure, or positive space, the primary volume.

There are many variables to be considered when thinking about elements and properties. Tables One ("Artistic Variables of Elements in Photography") and Two ("Artistic Variables of Properties in Photography") summarize them.

◼ ILLUSION

A photograph is an illusion of what has been photographed. A still image has no movement; instead, the eye moves throughout the photograph. A photograph has a flat surface, so there is no depth. It is two-dimensional rather than three-dimensional. To create a better rendering, then, you must identify ways to create illusions which make a photograph look more than two-dimensional.

Movement

There are several ways of creating realistic impressions of movement or activity. These rely on leading the viewer to make an assumption of movement. Action stopped at its peak, or something in a falling or diagonal position, suggests that movement is occurring. Another way to create the impression of movement is to show action that is blurred.

TABLE 1
Artistic Variables of Elements in Photography

ELEMENT	TYPE	CHARACTERISTICS
Surface	Smooth, glossy, luster and Matte, fine-grained, tweed, silk, tapestry	See manufacturer's samples
Masses	Spot	Instantly claims attention
	Disturbing Spot	Fights for attention with spot
	Double Spot	Forces eye to wander
	Visual Line	When three or more spots occur, imagery, or line, is constructed
	Visual Triangle	Three spots create triangle (caution: should not be parallel to side)
	Visual Shapes	Many spots forming a shape
Subject	Man, Other, God, Society, Nature, Preternatural	See "Theme, Subject and Message" on page 18
Photo limits or format	Vertical	(Higher than wide) suggests proud, upright, courage, action, and dignity
	Horizontal	(Wider than high) suggests peace, quiet, rest
	Square	(Wide as high) suggests forceful, clumsy, heavy, and strong
	Narrow	Suggests emphasis
Number	One, Few, Many	
Size	Actual, Under or Over	
Position or perspective	Background space	Upper half, lower half, not far off center and lower left
	Golden Mean (5:8 ratio)	Upper half, lower half, not far off center and lower left
	Symbolic	
	Camera Angle	High, low, normal
Pattern	Regular/Irregular	
Volume	Circle	(Top, bottom, left, or right) suggests eternity, without beginning or end, perfection and completeness
	Square	Suggests restful counterpoint and monotony
	Triangle	Upright pointing apex suggests vertical movement
	Rectangle	Suggests tranquility, depth and cold
	Horizontal/Vertical	Suggests action, proximity and warmth
	Irregular	Suggests natural origin
	Contrasting	Suggests emphasis on one when other is contrasted

Element	Type	Characteristics
	Detail	Partial shapes
	Extrapolation	Eye completes shape outside photo area
	Straight/Horizontal	(High, equal, unlevel) suggests stability, permanence, tranquility, and reliability
	Vertical	Uneasy or stable diagonal that may lead eye out of photo unless restrained by horizontal or vertical, most harmonious when rising from left bottom or right top. Tilting lines suggest convergence, height or depth. Diagonals give impression of toppling movement and action.
	Oblique	Suggests instability
	Contrasting	Brings out contrasted line
	Visual Shapes	Eye completes shape of line
	Irregular	Small or large undulation, curves, zigzags and angles suggest harshness, highly expressive and are termed artistic lines
	Grouping	Suggests visual shape between many close lines
	Jagged	Suggests sinuous, smooth quality, quiet or feminine
	Leading	Suggests direction for eye
	Lazy "S" Curve	Suggests romance, mystery and charm
Tone	Blue	Cold
	Neutral	Suggests contrast
	Brown	Warm
Rhythm	Even or uneven	Suggests accelerated or decelerated action
Edge	Square, rectangular, circular, irregular	
Composition	Static elements at rest	Suggests rest, peace, dignity, stability, firmness, security, strength
	Symmetry	Can be divided in half; suggests order and reverence
	Central	Eye is drawn to center of photo
	Dynamic	Elements not at rest; suggests action, motion, tension
	Pattern	Repeated shapes emphasizing abstract form or main quality of subject

TABLE 2
Artistic Variables of Properties in Photography

PROPERTY	TYPE	CHARACTERISTICS
Completeness of image	Complete	All parts visible
	Incomplete	Fewer parts visible
	Over-complete	More parts visible
Completeness of photograph	Complete	All parts visible
	Incomplete	Fewer parts visible
	Over-complete	More parts visible
Color	Warm	Yellow, orange
	Cold	Blue, violet
	Neutral	Black, white, grey, red, green
Texture	Smooth	
	Rough	
Depth	Surface	Objects look closer when nearer
	Size	Objects look closer when longer than others
	Contour	Lines recede into distance
	Overlapping	Overlapped objects are farther away
	Shading	Shows image as having form
	Density	Object looks farther away when light with atmospheric haze
	Foreshortening	Closer objects look larger
Motion	Freezing action	Stops action in tense position
	Sequence	Shows action advancing in a series of stills
	Blurring	Image blurred due to movement
Balance	Asymmetrical	Unbalanced position
	Symmetrical	Balanced by weight or interest
	Formal	Equally positioned in photo
	Informal	Unequally balanced in photo
Unity	Outline, space, contrast, color, ambiguity	
Clarity	Point merger	Images touch at one point of their outline
	Outline contact merger	Images touch above outline
	Axis or line merger	Distance image appearing to come out closer
	Tone mergers	Identical tones going into one another
	Color mergers	Identical colors going into one another
	Shape mergers	Shapes not being clearly defined
Dominance	All elements	
Duration		
Harmony		

Creating the Appearance of Depth

Surface: *Objects look farther away when positioned at the top than when positioned at the bottom of the frame. The man on the right appears closer because he is lower in picture.*

Contour Lines: *These curving surface lines control the direction of objects that are cylindrical in shape. Curves going up appear to move forward, those going down appear to recede.*

Shading or casting: *If an object is partly in light and partly in shadow its surface cannot be flat but must really be curved or bent.*

Size: *Objects known to be similar in size will appear more distant than similar objects when shown as progressively smaller. Using three depths in a photograph, foreground, middle ground and background, can emphasize size, because the eye picks out three distinct planes.*

Foreshortening: *Reduces or distorts an object and shows one edge of an object closer.*

Aerial perspective: *Objects that are lighter, blurred or hazy appear distant due to atmospheric partials.*

Overlap: *An object appears nearer if it seems to "cover" another.*

Photographers can also try the following effects:

- Subject motion (panning)
- Camera motion
- Both subject and camera motion
- Sequence of prints
- Sequence of subjects in prints
- Multiple exposures
- Flash with long exposure, strobe effect, etc.

Depth

Depth, or linear perspective, is a technique for showing spatial relationships on a flat surface, giving the illusion of a third dimension. This perspective appears to some degree in all photography. When exaggerated, it makes one object appear closer and the other farther.

> *Give the illusion of a third dimension.*

Composition and lens choice are easy ways to emphasize depth. Shallow depth of field is an additional way to show depth. By using a more wide-open aperture, the foreground can be blurred. This is how the eye sees. Other ways to create the appearance of a third dimension are presented in the accompanying sidebar ("Creating the Appearance of Depth," page 35).

Other guidelines to consider when trying to suggest depth are:

- A light-toned subject looks closer than a darker subject.
- A subject moving toward the camera looks bigger.
- A subject close to lens looks bigger than an object far from the lens.
- Warm (browns) tones appear to come forward while cold (blue & green) tones tend to recede.

- Looking up at a subject from a low camera angle accentuates depth, while looking down flattens it.
- A subject that rises to the horizon has the subtle effect of depth.

■ MERGERS

A merger occurs when two or more images appear to be joined. Mergers can make photographs hard to understand, but can also produce mystery or create unusual effects. Mergers can falsify and make objects become invisible. They can also destroy the illusion of depth by bringing merged objects to the foreground or background. There are several types of mergers in photography. These include: point merger; outline continuation merger; line or axis merger; tonal merger, and shape merger. Each of these types is demonstrated in the sidebar entitled "Types of Mergers" on page 37.

■ HINTS

These guidelines are generally held as important to follow. They need to be considered to see if they are relevant to your image in the evaluation stage.

- Strong and natural horizontal should be horizontal.
- Strong vertical should be plumb.
- Sharpness, brightness and warm tones are what the eye seeks.
- The eye will jump to areas of greater tonal contrast, shift back and forth between areas of equal contrast or interest, and imagine lines between spots.
- The human eye will search for human presence in a photograph, regardless of design.
- "Gaze" space should be given to a subject who is not looking at the camera.
 - In dark photos, light attracts.
 - In light photos, dark attracts.
 - Repetition can unite elements in

the scene and create rhythm, pleasing the eye by repeating emphasis. When a pattern has been established, the eye will fix on any variation, so objects interrupting patterns introduce tension.

- Round forms or curving lines should be cut boldly and should not touch the edges of the print.
- Diagonal lines should not exit the corners of a print.
- A subject in motion should have more space in front of it than behind it.
- Action usually proceeds along a line or forms from left to right.
- Horizons that divide the photo into two equal parts are monotonous.
- Leading lines draw the viewer's eyes to the center of interest.
- An "S"-curve produces interesting photographs.
- Intersecting lines attract notice.
- Vertical and horizontal lines are stable and can suggest order.
- Diagonals can suggest imbalance or action.
- Larger negative space accommodates the thrust of design.

■ LIGHTING

The roots of the word photography mean "writing in light." Light is an extremely important variable that can be used as you found it, or supplemented with other sources. Position and contrast of light sources should be determined in relation to the effect you want. Use Table 3 (supplied on page 36) to vary the combinations of light.

You may wish to keep the following guidelines in mind:

- Front lighting comes from the camera position and casts few shadows.
- Axis lighting comes from the lens, casting a shadow around the outline of the subject.
- Side lighting can come from either side of the subject. It casts a shadow on

Types of Mergers

Point merger: *Occurs when two or more images touch each other at a point of their outlines.*

Line or axis merger: *Occurs when two or more images coincide by touching or continuing their axis. The tree coming out of someone's head is a frequent example.*

Tonal merger: *Occurs when two or more images of identical, or near identical, tonal value are placed beside each other.*

Outline continuation merger: *Occurs when outlines of two or more images continue through each other, even though there are breaks in their continuity.*

Shape merger: *Occurs when the dominant shape is lost in other similar shapes.*

Outline contact merger: *Occurs when one or more images touch each other along any length of their outlines. They look stuck together.*

the side of the subject opposite the light source.

☐ Direct lighting is strong-edge light making dark shadows.

☐ Directional-diffused lighting is soft-edged with a directional quality.

☐ Diffused lighting has almost no shadow.

☐ Silhouette lighting makes the subject dark and the background light.

☐ High contrast lighting occurs when there is a great difference between the highlights and shadows.

☐ Low contrast occurs when there are mostly middle gray tones (little difference between the highlights and shadows).

■ SUMMARY

This chapter lists many of the variables for different themes and the broad aspects of design. In PhotoStorming, as many variables as possible are considered in solving a visual problem, that is, when making a creative photograph. These variables are listed and defined to help you in the creative process. You may want to study many of these broad areas in greater detail.

Table 3
Light PhotoStorming

The following are selected categories of light. Select combinations among these categories to change and improve your photograph. You might take one item from each column and combine them to create a different light arrangement. For example: strobe, side, key and film. Make a portrait of a subject using a key strobe light on the side of the face with high-speed film (with the effect of overexposing the face and creating high grain).

SOURCE	POSITION	CONTRAST	MISC.
Available	Key	High key	Film
Lamps	Fill-in	Very soft	Filters
Bulbs	Background	Soft	Attachments
Electronic flash	Effect light[1]	Medium soft	Illumination/shadow
Strobe	Overhead	Medium hard	Multiple flash (strobe)
Umbrella	Side	Hard	Multiple exposure
Spot	Back	Blocked-highlight	1/2-frame advance[2]
Trough	Filtered	Low key	Color source[3]
Fluorescent	Side/back	Patterned	Time of day
Quartz	Reflected	Mist	Time of year
Tent	Light-painting[4]	Background-dropout[5]	Area of world
Floodlights	Direct	Shadow flash[6]	Film/paper development
Ring light flash	Multiple-direction	Colored light source	Combination
Combination	Bottom	Combination	Lens mask

1. Effect light provides more than one highlight, usually coming from the back or side. Used for glamour, to separate background or suggest an interesting background activity (such as in theater).
2. Multi-exposure sequence against an unlit background taken at half-frame windings on roll film camera.
3. Colored gels are used in one light source.
4. Where subject is lit by waving a light on the scene as though it were brushed on a painting.
5. Subject is lit with flash and background is under-exposed, usually where fill is stronger than scene.
6. Shadow flash is term for background-dropout, where subject shadow is included in the scene.

③

The Camera

CAMERA VARIABLES/ CAMERA VISION

You may know the basics of how a camera works, but do you know what a camera can do? This chapter is about types of cameras, lenses and creative controls.

There are accepted qualities by which photographs are judged, such as the sharpness derived from perfect focus. The most common reaction people have when they look at a photograph is, "It's a really good photograph—it's so sharp and clear!" Sharpness, and the illusion of sharpness, are created by film grain, camera and enlarger focus, depth-of-field focus, lens resolution, shutter speed, camera steadiness, highlight detail and other characteristics.

You might ask yourself why sharpness is generally considered part of an acceptable photo. For that matter, you may ask why we print rectangular photographs when we see in a circle? Why do we try to achieve depth or the feeling of movement when the medium is flat and still? Much of what we do depends on what has been accepted in the past. We are conditioned by what we observe.

Many of the creative controls we exercise, and the criteria we strive to meet, are functions of the equipment we select and how we use it.

HOW THE EYE SEES VERSUS HOW THE CAMERA SEES

Before we get into the specific variables of photography, we need to consider some of the ways in which the human eye sees differently than a camera "sees."

☐ The eye can only focus to a shallow degree, but the camera aperture can vary, allowing an almost infinite depth-of-field sharpness.

☐ Film "stores" light. As a result, film can record detail in areas where the human eye cannot see, such as a dark room.

☐ The eye sees peripherally about 180°, but the camera selects the subject and can crop out surrounding areas, usually in a rectangular format.

☐ The eye always sees a full spectrum of color, while film can render a scene or subject in black and white.

☐ We see in conjunction with other senses like smell, touch, taste, and sound, but photography is purely visual.

☐ The eye selects what the brain is aware of, but film renders everything. If you are not conscious of something, you don't see it—but the camera does.

☐ We can see three-dimensionally while the camera creates a flat or two-dimensional image.

☐ With a fast shutter speed, the camera can stop a moment in time. With a slow shutter speed, it can show movement while the shutter is left open and the subject moves.

☐ The camera can go where the eye can't, such as internally to look for health problems. Cameras can also go where it isn't safe for us, such as into a radioactive environment or the earth's crust.

In terms of other mediums, a photograph provides an *illusion* of reality, as opposed to a painting which creates an *interpretation* of reality. In some cases, the camera increases our vision—we can't go to the moon, but we can see photographs. In other ways, it limits our vision and forces us to create photographic illusions to portray the way the eye sees.

You must always challenge your vision.

CAMERAS

It seems that the first question I am asked in beginning photography classes and photography workshops is, "What is the best camera to use?" Although there are cameras that have specific purposes, having the right camera is not what makes a photograph, but rather how the photographer "sees" (and uses all the photograpic variables to interpret what he sees). Famous photographers have made exciting photographs with "inferior" cameras because the photographer knew how to "see."

Camera Systems

All cameras have six basic systems: viewing; focusing; metering; shutters; apertures and lenses.

Viewing. There are several things to consider in a camera's viewing system.

In a twin-lens reflex (TLR) camera, separate lenses are used to view the images and to expose the film. The viewscreen is located on top of the camera, so you look down into it, holding the camera at waist level to focus and compose images. This comes in handy when holding the camera over your head in a crowd since you can turn the camera upside-down and look up into it to compose the photo. However, a parallax error (the subject/object isn't in a straight line) can occur when photographing a subject close-up with a TLR camera, because the two lenses don't line up correctly at short distances.

A rangefinder camera has some of the same characteristics as the TLR, but the subject needs to be viewed at eye level. The subject is viewed through a viewfinder with its own small lens. This is usually located directly over the main lens, by which the film will be exposed.

A single-lens reflex (SLR) camera uses a mirror system to allow you to focus and compose your images. Light coming through the main lens (which will be used to expose the film) hits a mirror and projects onto a viewing screen. This system allows you to preview the image exactly as it will hit the film. Because of the distance the light travels in these cameras, the SLR is more difficult to focus in low light. To maximize the light on the viewscreen, images are normally previewed at the widest aperture allowed by the lens. This means that the depth of field will appear very shallow—often more shallow than it will will appear in the final photograph (depending on the aperture selected for exposing the film). Some SLR cameras offer a depth-of-field preview function to compensate for this.

Focusing. Focusing may be accomplished through either manual or automatic systems. Some cameras offer both.

Manual systems require the photographer to adjust the focusing ring on the lens while previewing the image. As the ring is turned, the photographer can choose to focus on one or more subjects within the frame.

Automatic systems automatically attempt to focus on what the camera interprets as the subject of the photograph (normally something in the center of the frame). Many auto-focus cameras offer a focus-lock feature whereby the photographer focuses on the desired subject, then locks in the setting by depressing the shutter button halfway. While continuing to hold the shutter button, the camera can be moved and the image re-composed without losing the focus on the desired subject.

The single-lens reflex (SLR) camera is the most popular and versatile type used at eye-level. Unlike TLR or rangefinder cameras, significant movement occurs within the camera during exposure. When the shutter is depressed, a mirror pops up, the aperture opens or closes to the setting indicated by the photographer, and the shutter goes off. This movement can cause vibrations which detract from perfect focus by causing camera movement.

Metering. There are various systems for in-camera metering that determine correct exposure. These are called reflected light meters because they measure the light reflected by the subject back to the camera. There are in-camera meters that measure the average light reading for the entire frame, as well as meters that read within a limited angle of view for close-up readings of reflected surfaces.

There are also external meters which can be used to measure the incident light (the light that falls on the subject). The most precise metering system of all is the spot meter. This device allows you to measure the light falling on a very small area of your subject, rather than on the area as a whole.

Types of Cameras

Generally, the larger the camera and film size, the higher the resulting image quality, the more expensive the camera system, and the heavier it is to carry.

Cameras range from the point-and-shoot type, to view cameras, to specialty cameras such as the Polaroid®. Many of the features are similar, like the basic operation of shutter and aperture, but other features, such as mirror lock-up, size and type of film, multiple exposure operation, distortion control, depth of field, automatic-focus and remote control, may vary.

Point-and-shoot. There is great ease of operation in these simple 35mm cameras, which have lens quality nearly as good as their more complex counterparts. Features like zoom and a variety of flash settings are becoming standard on point-and-shoot cameras, but they are still limited. You cannot simply add

(Top) This photograph was made with a Stereo Realist camera. To view this print place it in front of your eyes about a foot away and slowly cross your eyes. The two images will separate and slowly form a third image in the middle. This is the 3-D image. It takes practice to see the effect, so be patient.

(Right) Photograph made with Panoram-Kodak No. 1 camera (manufactured c. 1900). There are only "fast" and "slow" shutter settings on this swing lens camera. I chose ISO 50-film speed because of the slower films that were made for this camera. The model is running in the direction in which the lens is moving.

lenses to these camera systems, for instance. They do, however, make great vacation and daily-use cameras because you never have to worry about aperture settings, etc.

35mm SLR. This workhorse camera is currently the camera format that most professional photographers use. It has a wide variety of features and you can attach special purpose lenses, but it is heavier and more complex to use than 35mm point-and-shoot cameras. On all 35mm cameras, because the film size is relatively small, errors are magnified when images are enlarged significantly.

I always suggest using a manual 35mm rather than an automatic 35mm, as the creative variables are easier to access on manual models. It is difficult to override settings on an automatic 35mm. Another rea-

son many professionals choose this format over larger ones is the availability of automatic focus, shutter and aperture priority settings, as well as automatic metering, digital features, motor drives or winders, double exposure features and microscopic capability.

Medium Format. The medium format camera is primarily used when increased resolution from a larger negative is important. With photographic artists, this format is more popular than 35mm because of the increased quality of enlargements. Both square and rectangular film formats exist in the twin-lens reflex, single reflex or ranger finder models. Medium format cameras also have interchangeable film magazines, magnifying hoods and prism finders in 120, 220, or 4x6 to 6x9cm films. Polaroid® backs are another

popular option available for medium format cameras.

Large Format. The large format view camera can't be beat when it comes to negative resolution, bellows for close-up photography, more camera adjustments for distortion control, and precise depth-of-field focus. The down side is that the lenses are slower and the cameras are difficult to work quickly. View cameras have sheet-film that can be individually processed. Other available accessories are Polaroid backs, roll film backs, film packs and ready-load film. Film sizes range from 4"x5", 5"x7" to 8"x10" and larger.

Special Cameras. There are a wide variety of specialized cameras which can be used to create special effects or in unique circumstances. These include panoramic, pinhole,

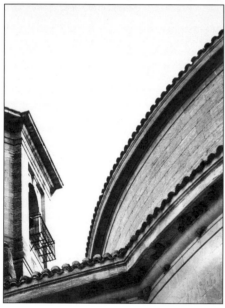

(Above) Finding the correct exposure was difficult as the sun was rapidly descending below the horizon. I doubled the shutter speed (F/32 at 10 minutes) from what the meter read. I then printed the image with a more graphic effect. (Left) A slow shutter speed was used (F/32 at 3 seconds) with both a red and yellow filter to further slow the meter reading for the shutter speed. There were many birds flying around or in their nests. The long exposure leaves us with the bird nests, minus the birds.

and 3-D cameras. There are also miniatures, aerial, and underwater cameras, as well as cameras that can be recycled.

Panoramic cameras can have a fixed lens, a swinging lens or a rotating lens. The angle of view varies from model to model. Something I particularly like about the swing-lens panoramic camera is that a moving subject going in the same direction as the swing will be elongated, and if the camera is moved in the opposite direction, a moving subject will be compressed.

A pinhole camera provides great depth of field, soft rendition of detail and delicate tonalities. In general, the smaller the pinhole and longer the exposure, the better the focus and depth of field will be.

3-D cameras have enjoyed a recurring popularity over the years. Normally, the images are not printed but are seen through a viewer.

Currently, Polaroid® cameras are popular because photographers can manipulate and transfer Polaroid® images in creative ways. The latest in technology is the digital camera, which offers immediate viewing of an image in the camera. The image can be downloaded into a computer, then worked on and printed.

■ SHUTTERS

The two types of shutters are leaf and focal-plane shutters.

The focal-plane shutter is noisier than the leaf shutter and only allows flash-synchronization speeds up to 1/200 second. The focal-plane shutter has two curtains operated by a spring and gear mechanism.

Leaf shutter systems are quieter and will synchronize at fast speeds.

Shutter Speed

The shutter speed determines how long light strikes the film. It is an important factor in exposure. Shutter speed also allows you to freeze action, or emphasize movement. Practice will help you determine the appropriate shutter speed, especially for moving subjects.

If the circumstances allow it, make several exposures—some greater than and some less than you think are required. This is called bracketing; the intent is to safeguard a correct exposure in at least one frame. This technique is usually used when you are in doubt about overall exposure, but may also be used when working to capture motion.

Slow shutter speed with partial subject movement. When a slow shutter speed is used the camera needs to be on a tripod. The subject should be moving quickly enough to show subject movement on the film.

Slow shutter speed with camera movement. This is also called

Planes of Focus

A	**B**	**C**
D	**E**	**F**

Different planes of focus can highlight the paints, the painter and the background. A medium-long lens was used to illustrate shallower depth of field. The foreground was at 7 feet from the film plane, the middle ground was at 10 feet and background was at 15 feet. Photo A shows the complete depth of field of all planes. In Photo B, only the foreground is in focus. Photo C shows only the middle ground in focus. In Photo D, only the background is in focus. Photo E shows the foreground and middle ground in focus. Photo F shows the middle ground and the background in focus.

Shallow depth-of-field from a low angle. This photograph (F/5.6 at 1/500 second) would not show as much depth if it wasn't shot from a low angle.

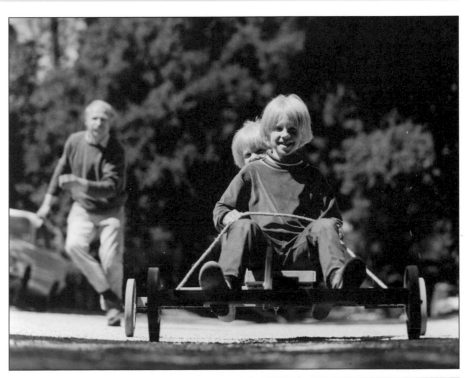

an "overpan." While holding the camera steady, you can move it up or down, back and forth, or in any direction while the shutter is open.

Fast shutter speed stopping subject action. It's always a challenge to know what speed to use to freeze a moving subject. It depends on the speed of the action. Slower shutter speeds can be used if the subject is coming toward or going away from the camera, rather than crossing the path of the camera.

Panning. This requires that the camera follow the movement of the subject at the same speed allowing a slow shutter speed to blur the background and foreground. Swing the camera in an arc to follow subject movement. Start panning before you depress the shutter.

Removing a moving subject(s). Using a slow shutter speed can remove objects. But note that after one or two seconds' exposure, the film begins to build contrast.

Aperture

The aperture controls the amount of light striking the film and the depth of field. The depth of field is the in-focus range in front of and beyond the subject on which the lens is focused. Using a smaller aperture setting (higher f/number) will increase depth of field (provide a greater range of sharpness). Using a wider aperture (smaller f/number) yields a narrower depth of field (smaller range of sharpness). By changing the depth of field, you can change the focal point of a photograph.

Shallow depth of field. A shallow depth of field best simulates the way the eye sees. It accentuates the subject standing out from the

(left) This photograph shows a lighter all-over tone with considerable detail in shadow. (Right) This version of the photograph shows a darker background with little or no detail in the shadow area. The printable range was changed

out-of-focus background, giving the viewer a feeling of depth.

Shallow depth of field from low angle. Moving from eye-level to a lower position can provide a strong feeling of depth.

Infinity depth of field. This is when the maximum acceptable depth of field possible is used so that the foreground and background both appear sharp.

Exposure Setting

An exposure is considered "normal" when the combination of aperture and shutter yields tonal values very close to what the eye sees. Testing is often necessary to determine the "normal" exposure for any given photographic paper and film. However, you may want to show more detail in the shadow area of a particular image than the eye can see. To achieve this, you might want to "creatively" shift the tonal scale.

Over-exposure. This occurs when more than "normal" exposure is given to a negative. It sometimes

yields a negative with more grain and shadows which are blocked up (dark and lacking detail). This makes the blacks difficult to print.

Under-exposure. This occurs when less than "normal" exposure is given to a negative. Usually, highlights in the print are dull, or the negative is flat (lacking contrast).

■ LENSES

The lens collects light rays from the scene or subject. Different lenses have specific characteristics, such as: speed; angle-of-view; perspective; depth of field, and optical quality.

Speed refers to the diameter of the lens. The faster the lens (the larger the diameter) and shorter the focal length, the more light will reach the film.

The angle of view is the amount of scene the lens includes.

Perspective describes the relationship of objects to each other within the photograph. The perspective changes if the distance

between the lens and the subject changes.

Depth of field. Larger lens apertures yield a narrower (reduced) depth of field, while smaller lens openings yield a larger (increased) depth of field.

Optical quality (or lens sharpness) is measured in resolving power. This is the capacity of a lens to produce a sharp image. Lack of lens sharpness and lens flare (the internal reflection off the surfaces inside the lens, causes a ghost image) used to be quite common problems. These have been corrected in most newer cameras, but cameras without these technological refinements can still be used for their aesthetic effect.

Focal Length

The focal lengths of lenses range from short (or wide-angle) to long (or telephoto). The normal focal length of the camera is determined by the film size of the camera and approximates the angle of view of the human eye. What may be a "normal" lens for one format camera may be "long" for another format. For 35mm cameras, the normal focal length is 50mm. Lenses shorter than this are considered short or wide-angle lenses. Lenses longer than 50mm are considered long or telephoto lenses.

Short focal-length lens. With short lenses, the camera needs to be closer to the subject than with longer ones. When using these lenses, take perspective into account as horizontal and vertical lines at the edges of a scene often appear curved. If the lens and subject are perfectly parallel to one another, the perspective is exaggerated, but the relative size of objects in the

This photo was made using a 17mm fisheye lens on a Pentax camera.

scene remains proportional. If the lens is not parallel but at an angle, objects nearer the lens appear larger and out of proportion to the ones farther away. A wide-angle lens provides a feeling of space and has a good depth of field, allowing for fast action close to the camera.

Long or telephoto lens. A long lens allows the photographer to crop out the foreground, compact the background, and blur the background. This is because telephoto lenses render perspective differently than normal lenses, making it more difficult to see the real distance between objects in the photograph. It is always a good idea to use a tripod for long or telephoto lenses, especially when using a slow shutter speed. This will help to eliminate camera movement with these heavier lenses.

Special Lenses

For fun or unusual effects you might try a panorama, zoom, close-up, fisheye, perspective correction, portrait lens or a long lens with mirror elements.

A fisheye lens is a good choice when you want to create fantasy. Lenses shorter than 15mm can furnish a circular image in the center portion of the negative or on a full frame image. The circular image isn't corrected for rectilinear perspective, while the full-frame fisheye image is. Placing the horizon in the middle of the frame will minimize the distortion.

Fisheye lens attachments, along with a bird's eye attachments that produce 360-degree images, are also available.

Shift lenses are designed to correct vertical distortion and can also be used by rotating the lens horizontally to produce a wide or semipanoramic effect. For a stab effect, you can move the camera by degrees and multiple expose.

Mirrored lenses are long lenses that are shorter and lighter in weight than most and have unique tiny dots of light that are out of focus. The dots are doughnut-shaped in appearance.

Zoom lenses have variable focal lengths. Pulling in or pushing out

This photograph was made with a 500mm, F/8, mirrored lens.

This photograph is hand-held at 1/15 second at F/22, and the lens is pulled out during exposure. If the camera had been on a tripod, the center rock would have been in sharp focus.

on the lens while photographing will give you an atypical image, simulating movement.

A macro feature on a zoom lens allows you to focus within inches of a subject. Perfect sharpness is not always possible with this combination, which also has slow shutter speeds.

A soft-focus lens is useful for portraiture as it retains the sharpness of the subject's eyes, while wrinkles and freckles are recorded slightly out of focus. Because it has historically been used in glamour photographs, the soft focus gives the illusion of a romantic scene or subject. The softness varies at dif-

ferent aperture settings. You can also use filters, but the effects vary with these so plan to experiment.

Older lenses that have defects can be used creatively to produce interesting image flaws. The center of an image can be in focus while the edges are fuzzy, or vice versa. Tiny dots on a subject might appear tear-shaped on film. The perspective of a straight line might appear contorted on film.

◼ MULTIPLE EXPOSURES

When adding more exposures on one frame, you need to decrease the individual exposures so the film does not become too dense to print. For example, if you double expose you need to cut your exposure by half, or one stop. The following chart will help you determine your exposure setting.

2 images	-1 stop exposure
3 images	-1$\frac{1}{2}$ stop exposures
4 images	-2 stop exposures
5 images	-2$\frac{1}{4}$ stop exposures
6 images	-2$\frac{1}{2}$ stop exposures
7 images	-2$\frac{3}{4}$ stop exposures
8 images	-3 stop exposures

If each exposure is identical, the overlapping image occurs, and you get a ghost image. If the background is in even tones, you will be able to see this tonal change. You can also make multiple exposures where each exposure is different. This can be accomplished by a double exposure of a subject where the first exposure is normal and the second is reduced by one stop.

There are a number of variations of multiple exposures that you can try. Some of these are listed below.

◻ Exposures can be built up without any print-through of previously exposed images if a black background is used with

minimum reflection. Use the dark sky or non-reflecting velvet, and be cautious with your light.

☐ Multiple exposures can be done periodically over a long period of time.

☐ At dusk and night we can see shadow detail with our eyes, but it is difficult for the camera to register the contrast range. One solution is to photograph the scene at dusk and double expose it for the lights at night. Refer to the Appendix for a description of how this is done.

☐ If shadow detail is difficult to expose for in bright sunlight, you can get a fuller tonal photographic print by first exposing the sun and then making a second exposure for shadow detail after the sun sets.

☐ Pre-exposure is another way to decrease contrast in a photograph to make a more printable negative. (See instructions in the Appendix.)

☐ Whole-roll random multiple exposure can also be interesting to try. You never know what you might get using this approach, as it is difficult to control the outcome. By using the Multiple Exposure Charts, you can change the ISO and run a roll of film through the camera two or more times. You might try photographing pattern images for the first run of the film through the camera, then switch to close-up images for a second pass.

☐ A mask is a decive used to block or modify the light entering the camera. This allows the subject to move around an area and be seen in one photograph as being in many places.

☐ Use double exposure and shift focus. In one exposure, place the subject on a black background close to the camera, and in the second, the focus is changed and the subject is moved away from the camera. This expands the apparent depth-of-field range of the lens.

☐ BASIC FILTERS AND ATTACHMENTS FOR BLACK & WHITE

A filter is made of transparent material (gelatin, glass or acetate), and is placed in front or in back of the lens to affect exposure by absorbing some wavelengths of light, while allowing others to pass through.

Generally, same-color filters turn the object being photographed lighter in color. They turn their complementary color darker, thus changing the relative contrast. Colored filters work as follows:

Yellow (reduces blue, accentuates other colors). Yellow filters darken blue tones (such as the sky) and lighten skin tone.

Orange (reduces blue as well as green). Orange filters make the sky (and other blue tones) darker, but not as dark as a red filter.

Red (suppresses blue and green). Red filters make the sky) and other blue tones) darker. Combined with a

The first exposure captured strong detail in the foliage and path. The second exposure, made later, captures the light. Without special film development, this would be difficult to achieve in a single exposure.

Polaroid filter, the sky reaches its maximum darkness. Red filters improve the sharpness of distant subjects by reducing haze

Green (*reduces blue and red*). Green filters lighten foliage and emphasize skin tone.

Blue (*suppresses blue and reduces red and yellow*). Blue filters lighten fog and shadows.

Neutral density filters appear gray and absorb all colors of light equally. Neutral density graduated attachments darken gradually toward the edges, top, bottom or one side or the other. These filters reduce excessive brightness range, especially between foreground and sky. Rotating or moving the attachment can change the effect.

Use these attachments in a variety of ways...

Filters vary in intensity. There are four basic uses for filters:

❑ By absorbing a quantity of light, they allow you to use a slower shutter speed to exaggerate movement.

❑ By absorbing light, they also allow you to use a wider aperture for shallower depth of field.

❑ If the film speed is too fast for the bright scene, you can effectively cut the ISO by using a filter.

❑ They allow you to change contrast or lightness or darkness of different colors in the scene.

Special-Effect Lens Attachments

A polarizing filter allows you to remove or reduce reflection from water, oily skin or any smooth surface except metal. It also reduces contrast. You get the maximum effect of darkening the sky when the sun is at a 90° angle from the camera.

A vignetting attachment blocks the corners of your film and thus darkens the outside corners of your prints.

Diffusion attachments soften highlights and reduce contrast, but have little effect on sharpness. Some attachments diffuse the total image; others are designed to change only part of the image. You can also steam up the lens by blowing on it to get this effect. As the steam dissipates, the effect changes. This can soften the scene and helps reduce the appearance of skin blemishes. There is also an attachment that diffuses on one half of the circle, making an object look as though it is moving (the Cokin Super Speed). Another diffusion attachment is graduated, thus softening more as it radiates. Another is called center spot, making the image sharp in the center and soft at the edges. A soft spot is clear in the center and varies as it radiates from the center.

A split field attachment magnifies the foreground while maintaining background focus. This attachment is half magnifier and half unmagnifier, thus magnifying the foreground and making it focused. Between the two fields there is an out-of-focus line. Close-up depth of field is increased.

A double exposure attachment divides the lens in half, exposing one half and blocking the other. You make one exposure, reverse the mask, and make the second exposure. Use a small aperture and a tripod for the best results.

A double-image attachment is for making double images in each half of the print. The cross-screen attachment gives a starburst effect to brighten highlights. This attach-

ment comes in a variety of screens.

Multiple-image attachments can replicate the subject in two to six duplicate images, in parallel multiple images, or in a prism effect. A dark background and large aperture give a clear photograph. Images also appear closer with wide-angle lenses and farther apart with telephoto lenses.

Cross-screen attachments show streamers of light radiating from a strong light source. Adding soft-focus can give the photograph a hazy effect, or a misty or romantic feeling.

A diffraction attachment diffracts light in spectrum of tones without distorting the image. There are a variety of types (line, circles and bursts) available in these attachments.

Shaped frames in front of the lens (such as a keyhole) can change outside dimensions of photographs. This diffuses the area around a sharp center. The shape is sharper with a smaller lens aperture and the further away it is from the front of the lens.

When using many of these attachments, you should note effect created by changing the aperture.

You can use these attachments in a variety of ways—and you can even develop your own. Use theater gels, or anything that is transparent, as a filter or attachment to distort the image. Photograph on a reflective surface. Place a mirror in front of lens and photograph the subject's reflection on the surface or part of the surface. Project a slide image on another subject.

■ FLASH

There are many sources of lighting other than natural light. They

range from small reflectors to modeling lights and light boxes. Flash is a burst of electronic light going off at 1/10,000 of a second. Remember that the definition of photography is writing in light. A flash is light, so this is your writing tool. Use it both indoors and out. The flash is very versatile.

☐ Place it on-camera or off.

☐ Bounce off-camera flash into an umbrella, off a wall or onto a reflector.

☐ Use flash to balance existing light or to light something up that is not sufficiently lit.

☐ Use light from a flash to light up the shadows or dark areas of the subject or scene.

☐ Try a long exposure with flash on a moving subject. Trigger the flash, then leave the shutter open. The flash will etch the subject in sharply on the negative, and leaving the shutter open will blur the movement of the subject.

☐ Painting with light means using a light source to illuminate a dark area by moving the light around the area. Use a flash with multiple exposures to build up enough light for a proper exposure.

☐ Create a stroboscopic effect by triggering multiple flashes on a moving subject. It usually requires a dark background.

☐ Using the flash as the primary light source can stop action faster than the shutter.

☐ Multiple flashes with multiple exposures, or long exposure, can be used to light subjects in a variety of positions and areas of the frame.

☐ Combine flash with other light sources, like a flashlight, to light a subject and then light up another subject in the photograph.

■ SUMMARY

Camera variables are just one way to create illusions, and must be considered not only as technical devices, but also as creative tools. Camera variables should become so familiar to you that you use them without instruction, either on location or by pre-visualization. With practice, camera variables can extend our creative vision.

Three flashes were made on each side of columns during the long exposure. The ceiling light was measured, and the aperture dropped down to lengthen speed to make six exposures.

This photograph combines the use of a flashlight and a flash. The flashlight was used to draw around head and while the shutter was open. Meanwhile, the flash was used to freeze the subject's image in the frame.

4

Film, Printing and Display

Photographers either pre-visualize or post-visualize their work. In pre-visualization, the photograph is fully conceived before the film is exposed. In post-visualization, the concept comes to fruition after the film is exposed, particularly in the darkroom. As you become more familiar with these techniques, you will gain more control of your visual expression.

■ COMMON FILM TYPES

Selecting the appropriate film and processing are essential for a fine print. This section discusses the different types of films and some of their uses. All film is sensitive to a particular light spectrum.

Gain more visual control of expression...

Panchromatic film is sensitive to all colors the eye perceives, but is also more sensitive to ultraviolet light. As a result, blues are darker on the film and print lighter. These films are the most widely used today and have the widest range of speeds.

Chromogenic film creates images with dye, not silver, often with great exposure latitude.

Orthochromatic film is less sensitive to orange and red light. It can be developed in a continuous tone or with high contrast, depending on the developer. This film is more sensitive to ultraviolet, blue and green light. Thus, it is often used for copy and graphic arts work.

Blue-sensitive films make ultraviolet and blue darker and are used for copy work.

Instant film uses no darkroom. Chemicals are usually added in the film package. Instant film, however, is not to be confused with the instant print.

Polaroid® film is a negative and a print combination that can be adapted from 35mm to 8"x10" size. Emulsion transfer prints can be made from Polaroid materials. This is where the emulsion is taken off the paper base and relocated on a new base.

Infrared film creates an ethereal, haunting, mysterious or surreal look, with an increased appearance of grain and a glow in brightly lit areas. This film is sensitive to both visible light wavelengths and invisible infrared wavelengths, but visible light is normally blocked out by the use of a red filter.

Foliage, grass, human skin, clouds, buildings and sand can appear white. The sky appears dark because it does not reflect light, so there is a bright contrast between clouds and sky. There is no consistent relationship between the color of an object and the number of infrared rays that are reflected.

Lithographic film produces an image with very high contrast and fine, uniform grain size. This film is usually available only in sheets, and is used in photomechanical reproduction. It can be used as a continuous-tone or high-contrast film. It is used for copy enlargements for many of the contact-print processes such as Platinum, Van Dyke Brown and Cyanotype.

Reversal or positive film records a positive image on the film, so if enlarged in the darkroom a negative print is produced. This film is usually used for slides.

■ FILM DEVELOPERS

Film developers can be purchased as ready-mixed liquids, or the ingredients can be purchased and mixed from scratch. Developers affect grain, acutance (the contour or edge sharpness), overall sharpness, contrast, tonal value, resolution and speed of film. Combined with different films, developers may have unique properties.

There are four basic components in film and paper developers:

❑ Developing agent reduces silver halide to metallic silver.

❑ Preservative controls the developer oxidation.

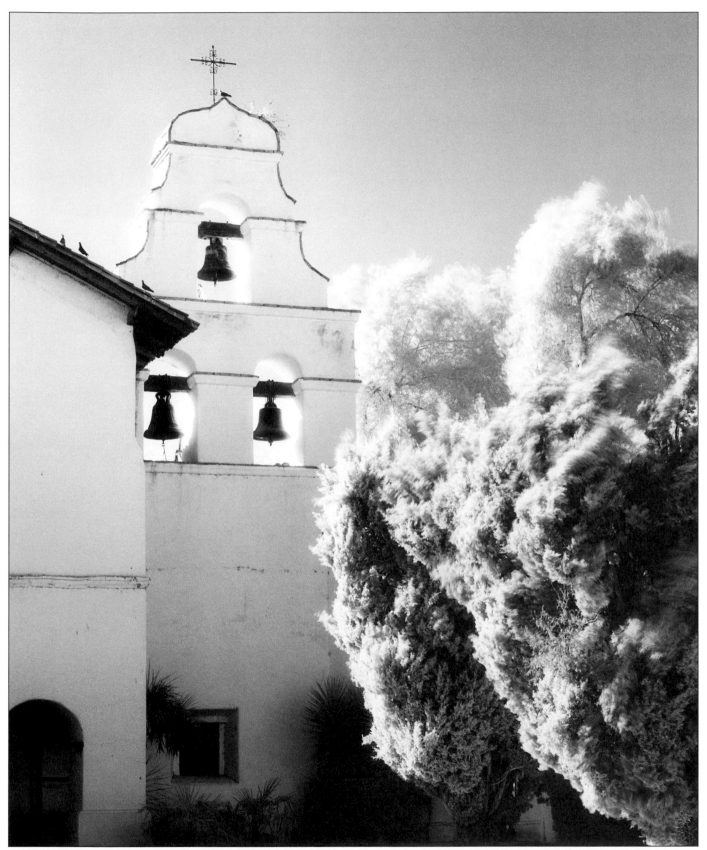

Konica infrared film was used at ISO 100, with a Wratten 25 (red) filter. Exposure was 1/60 at F/16 in direct sunlight. Other filters commonly used with infrared film are Wratten 15, 29, 70 and 87C (opaque). Because infrared light focuses on a different plane than visible light, the infrared focus mark on the lens was used. Notice how the dark colors create contrast, and the whites tend to merge.

This photograph combines the use of high-contrast litho film with the Sabattier effect on film.

❑ Accelerator energizes the developer.

❑ Restrainer controls the rate of development and restricts film base fog.

Each component can be altered to change the final effect.

The general types of film developers are listed below. Testing and experience with each of these will help you choose the appropriate developer.

Divided developers, water bath developers and **compensating developers** can control contrast in the high values of the negative without affecting shadow and the middle values of the negative.

Fine-grain developers can improve fine grain while still controlling contrast.

Coarse-grain developers accentuate grain. They usually work best with thin-emulsion and slow- to moderate-speed films.

High-definition developers are used to improve acutance or sharpness.

Other developers increase contrast (high-energy developer), decrease contrast (low-contrast developer) or push film speed (push-processing developers).

Development Time

Change in development time has little effect on shadow, but it does affect the highlight. Overexposure and less development yield rich shadow. Underexposure and more development give more contrast.

■ FILM CHARACTERISTICS

All the characteristics discussed here can affect the impact of the final print.

Grain is the size of silver molecules in the negative. Grain quality is in the film. Normally the faster the film (the higher the ISO number), the more apparent the grain. In recent years, new film technologies have helped to provide a reduced appearance of grain, even in higher speed films. Therefore, the appearance of grain in a print is controlled by:

❑ The type of film

❑ The type of film developer

❑ Excessive agitation

❑ Development time

❑ The temperature of the developer

❑ Amount of exposure

❑ Type of enlarger

❑ Size of enlargement

❑ Changing solution temperatures between steps in the chemical developing process.

You can create the illusion of grain with a screen. You can also lessen the illusion of grain by making the enlarger slightly out of focus or using a textured printing paper.

Acutance is the contour or edge sharpness. It describes how clear and sharp a line is between two objects on the film. Slow films developed in high-definition developers produce negatives with high acutance.

Sharpness relates to the transition between a light and dark tone. The photograph looks sharp if the transition is abrupt, and inferior if it is gradual.

Contrast is the difference in density between the dark and light areas of a photograph.

Tonal value is the gradation, or total range of density.

Resolution is the reproduction of fine detail. The choice of lens also affects a photograph's resolution.

The characteristic curve describes the way developers, agitation and exposure affect a particular film. The curve shows a film's tonal range and contrast with different development times. All these characteristics function interdependently with film development.

The more light that strikes the film, the denser the negative. With underexposed film, shadow areas and mid-tones are thin and poorly separated, with loss of detail. With overexposure, the mid-tones and bright values result in little tonal separation and loss of detail. The shadow values show tonal separation and detail.

> *You might try extending development time.*

The developer, development time, temperature and agitation affect density—especially for bright areas in the print. You can control variations with testing, especially for ranges of light which don't fit into the film scale. For example, you might try extending development time with a dilute developer and decreasing the film scale to record a high-contrast scene.

Film reducers remove density from resulting from overexposure or overdevelopment. They can be used on all or part of a negative. Some reducers begin to reduce shadows then affect the middle-value, and highlight areas. Others reduce all areas equally. Still others work on highlight areas more than on shadow areas.

Film intensifiers increase density in underexposed and underdeveloped areas. They can be used over a whole negative or localized. They are proportional, however, and some are more effective in the shadow areas of negatives.

The original film was color transparency. A 4 x 5 negative was made and then contact printed. The enlargement was retouched for balance and printed slightly off register.

Reticulation distorts the emulsion layer of film in patterned clumps. It can look like grain. Subjecting film to extreme temperature changes during processing reticulates the film. This effect is permanent.

Halation, blurring or halos around the images, occurs when excess light passes through the film and reflects from the film support.

Solarization (in the camera) can occur with long exposure to extreme brightness.

▪ FILM PROCESSES

There are several methods of developing film in order to create different print effects.

High-contrast film can be used to delete middle grays, making a black-and-white image. It is useful for retouching, enlarging and eliminating detail by cropping. It is also used for making multiple images and rearranging composition.

Tone line is made from a litho film. The original negative or continuous-tone enlarged negative is slightly out of register. It can be contacted or enlarged. A contacted film is placed directly on photographic paper or another film, pressurized, and then exposed to light to make another image. This produces an image that has a small distortion and is higher in contrast. Varying the negative den-

sity can also produce different effects.

Bas-relief combines negative and positive films taped together slightly off register. The light for the exposure is placed at a 90° angle so a line is created by the thickness of the film when both positive and negative are placed together. This can be a final print or a third negative. The result is a linear image that looks like a pen-and-ink drawing.

Posterization separates the tonal ranges of the negative by using high-contrast film. Make two or three litho transparencies of different densities from an original slide or negative. The effect in a

print will be sharply defined gradations in tone.

The Sabattier effect (on film) is a partial reversal of the negative when it is briefly re-exposed to dim light while developing. The first exposure is the normal print exposure. Then, exposure to a dim light gives the negative and positive qualities and adds halo-like Mackie lines between adjacent highlight and shadow areas. This can also be done on the print, but the Mackie line in the negative process has more contrast. Another advantage of the Sabattier effect in the negative is that the photograph can be repeatedly printed the same way. Try using litho film for the Sabattier effect. Project a film image onto litho film and re-expose it to light during development. You can increase the Mackie line by making the first exposure out-of-focus.

■ SILVER GELATIN PROCESS

There are many subtleties that can be achieved in silver gelatin processing. Different papers have different characteristics. Developer affects papers differently. Restrainers can change the color of the image. Controlling these changes is the mark of the fine printer.

Silver gelatin is a jelly-like protein substance that binds silver halides to make the light-sensitive emulsion widely used today for prints and film. Most photographers use pre-coated papers, but just about any material (such as wood, metal, glass, and so on) can be used as a base for silver gelatin. The coating can be applied from a liquid emulsion which is available in kits.

Papers and Developers

There are three kinds of photo-graphic paper: chloride; bromide, and chlorobromide.

Chloride paper (Kodak AZO and Oriental Portrait) is slower and has a warmer, creamy-white tone.

Bromide paper (Brilliant, Agfa Brovira and Oriental Seagull) is faster and has a colder, black tone. Chloride paper is mostly a contact printing paper.

Chlorobromide paper (Elite, Kodabromide, Galerie, Ilfobrom, Agfa Portriga-rapid and all variable contrast papers) is a combination of chloride and bromide and is the most commonly used paper today.

Photographic papers vary in color, overall and internal contrast or scale, surface, speed and size. Using different types of paper, developers, dilutions, temperatures, restrainers, toners and fixers affects paper characteristics. Using different combinations can produce hundreds of possible results. Commercially prepared sample books may be of some help. The best way to understand the paper characteristic is to read the manufacturer's data sheets and articles, and then do your own testing. Papers change frequently. Different types of water (hard, soft, etc.) also affect them.

There are other types of papers to consider, as well.

High-contrast paper, like Kodalith Ortho Paper, which is a photomechanical reproduction paper, gives a high-contrast print. Left in the developer, it becomes darker and more contrasty. The tones range from a cold brown to a peach brown.

Monochrome papers have, instead of a white base, a colored base—like yellow, red, turquoise and green.

Instant print film from Polaroid offers other alternatives ranging from prints to a material with both print and negative together. Most need film holders for processing, and the film packs range in size from $3^1/_4$"x$4^1/_4$" to 8"x10". Instant-print film ranges from continuous tone, with a unique subtle luminosity, to high contrast.

> *Think of other media for your photographs.*

Mixed media. Think of other media for your photographs. Mixed media combines photography with other media, such as painting, sculpture, construction, masks and so on. Other types of material can be used to transfer prints to T-shirts, coffee cups, fabric (like pillow cases and banners), as well as buses, buildings and buttons.

Color

Color in a black-and-white print can be controlled by the combination of different types of developers and papers. Color differences are hard to see without comparing prints, but subtleties in color differences affect the viewer emotionally and are important for photographers to understand.

Warm tones (brown and reddish) engage the viewer and are frequently used in portraiture, still life and where the photographer wants an old or nostalgic effect.

Warm-tone prints can be achieved by using warm-tone paper and developing agents like glycin, chlorhydroquinone or pyrocatechin. Technique can also play a role here.

As prints develop, paper grain goes from yellow to brown and then, with full development, to

black. Therefore using developer that is exhausted can arrest development and create a warm tone. You might also try diluting the developer or lowering the temperature of the developer (to 65°F). Try increasing exposure and using a shorter development time. Try combining fresh and used developer, or using glycin-based developers. When mixing your own developer, try using less accelerator, like carbonate, or substitute potassium carbonate for sodium carbonate. A restrainer such as a 10% solution of potassium bromide can also slow development, turn the print brown and heighten contrast.

A warm print can also be obtained if you use toners, like sepia. A print that is dried quickly might also turn brown. Forced-air drying of a print may warm it.

Cold tones (blue) are less emotionally engaging and are frequently used with subjects like landscapes, buildings and abstracts.

Cold-tone prints are achieved from cold-tone paper, cold-tone developing agent, bromide restrainer and organic antifoggant (benzotriazole, Kodak antifoggant No.1). Full development is important.

You might use bromide papers, or gold tone with chlorobromide papers. A blue-toning bath may also be used, such as Iron Blue Toner. Try Amidol developer on both bromide and chlorobromide papers. Also try to prolong the development. A blue tone is harder to achieve than a brown tone.

Neutral-tones are achieved by full development. Use bromide papers with neutral-tone developer. Chlorobromide papers are fairly neutral, but they can go warm or blue, as noted above. Selenium

toner or Benzotriazole can limit the possible greenish cast. Dilutions of carbonate and bromide can also be mixed to balance color, enhance highlight and intensify blacks. Benzotriazole can be used to make black tones bluer.

Premixed Developers

There are some notable premixed developers.

Metol (Elon) and Hydroquinone produce soft and delicate images of good color. Prolonged development using these developers yields strong values and excellent color. Hydroquinone enhances contrast by building up heavier deposits in the middle and low values. This developer is long-lived and economical.

Phenidone (Ilford's commercial name) has a long tray life and can process large numbers of prints.

Amidol gives a rich and slightly cold black tone. When highly diluted, it gives a very soft image while maintaining reasonably consistent print color. Developing times may be as long as ten minutes. At a fairly high temperature (75°F), it gives an extremely rich and brilliant print. It also has a short life and a tendency to stain the print. It can additionally block the shadow values, texture and subtle values.

Glycin gives rich brilliant images when used in suitable combination with other ingredients. Selenium toning can modify this effect. With some papers, glycin gives a light "stain" in the very high values and highlights. This appears as a "glow." Glycin is a slow-working developer.

Three other good developers are the combination of Kodak's

Selectol-Soft with Dektol, Clayton Ultra Cold Tone Developer, and LPD.

Printing Papers

Test various papers. Use a standard negative with full tonal scale, and keep comparisons as you develop it using various combinations of paper, developer, exposure, and so on. Document the type of paper, the contrast grade or filter, developer and dilution, time in the developer, F/stop number and exposure time. This can be done on the back of the print so that it is easy to refer to in comparing your results. The following are some broad characteristics:

Base: Fiber to Resin Coated (RC)
Paper contrast: High to low
Tone: Warm to neutral to cold
Tint: Blue to brown
Texture: Rough to smooth to linen
Surface: Sharp to unsharp (Glossy, matte, textured, linen)
Weight: Single to double thickness
Speed: Combination of paper and developers
Grades: Graded to filter 0 to 5 grades

Paper has other characteristics, such as split toning, optical brighteners, dry-down time, tinting, toning, staining, etc.

Enlargers

There are three different types of enlargers.

Cold light, or **diffusion enlargers** slightly diffuse or soften images, meaning spotting is not as necessary and the appearance of grain is not as obvious. Diffusion works better for high-contrast negatives printed on filtered papers.

Condenser light enlargers accentuate contrast and crispness.

There is often greater need to retouch because blemishes from the negative are rendered on the print. Condenser light enlargers work well with low-contrast negatives and at a lower grain and acutance.

Point source light enlargers are the sharpest, but require more retouching for dust spots.

Contrast

Change in contrast can be accomplished in localized areas or the whole print. To lighten a print you can use one of these methods:

□ "Dodge," or hold back prints, giving selected areas less light during exposure.

□ Draw on the glass negative carrier with lipstick or grease pencil, using feathered, smudged or stippled strokes.

□ Use contrast-reduction masks which add density to negative shadow areas, balancing them with highlights.

□ Use reducer or bleach in selected areas, using Kodak Farmer's Reducer, potassium ferrocyanide or iodine

□ Intensify negatives by using selenium intensification or Chromium Intensifier.

□ Use soft lead or grease pencil on matte acetate placed in the glass negative carrier. This method of lightening a print is very precise.

□ Place Kodak Crocein Scarlet, a washable dye, over the areas on the negative to be lightened.

To darken a print, you can use one of these methods:

□ "Burn," or print-in, increasing the exposure in certain areas.

□ Split filtering is burning in with more exposure to selected areas using a lower-contrast-grade filter on filtered paper. It is quite effective with skies.

□ Use a Kodak diffusion sheet with a glass negative carrier and place petroleum jelly on the diffusion sheet in areas to be darkened. This cuts down on the amount of light printing through other areas.

□ Negative reduction permanently reduces selected areas.

□ Flashing (using dim light for a very short period of time to reduce contrast) darkens areas before or after the image exposure.

□ Full strength developer applied during development can darken prints.

□ Spotting can darken blemishes, disturbing spots or highlights.

Special Techniques

The following are more special techniques:

Linear distortion controls the way vertical lines converge when your camera is pointed up or down on a subject. This effect is especially common with-wide angle lenses and when shooting at a close camera angle to the subject—especially with subjects that normally appear vertical, like buildings. This effect is normally corrected in a camera that has swings and tilts, or a perspective correction lens.

In printing, the convergence of vertical lines can be changed by propping up the easel and/or tilting the enlarger head. When the easel is tilted, the proportions on the print equal those in the original scene only when the enlarger lens-to-negative distance is equal to the camera lens-to-film distance when the picture was made. With the easel tilted, you will get a greater magnification of height than width, resulting in a slimming effect. This slimming effect can be helpful in making more flattering pictures of people who may have been photographed from an angle that makes them appear short and stout.

Distortion control can also be used to exaggerate size and shape.

Other types of distortion. Bending the paper on the easel in printing can distort the image. To maintain sharpness, you need to decrease the aperture of the enlarger's lens. This will increase the depth-of-field. Another type of distortion can be achieved by rolling the easel during exposure. In a step-and-repeat print, the easel is moved to a stationary position and the print is exposed, and then moved again.

Vignetting is softening outside the perimeter by a gradual change of tone to isolate the subject or eliminate a distracting background. The effect may be to make the image appear to float. Vignetting can be done in the printing process, in the camera filter or as a camera mask that darkens edges. It can also be created in combination with a diffusion filter.

Diffusion softens or blurs all or part of the image. Diffusion can be done in the print or in the camera. In printing, diffusion helps blend backgrounds and reduce the appearance of blemishes, wrinkles, harsh light or coarse retouching. Use a stocking or other diffusion wrinkled, translucent material. The distance of the diffusing material from the lens controls the amount of diffusion. The nearer the material is to the lens, the greater the diffusion effect. With diffusion, highlights are degraded and contrast lessened, so you may also want to use a higher contrast paper. Also, try diffusing for only part of the exposure, say 1/3.

Diffusion can be done in the print or in the camera.

Textured screens are films or other devices that give the illusion of texture to the print. Commercial

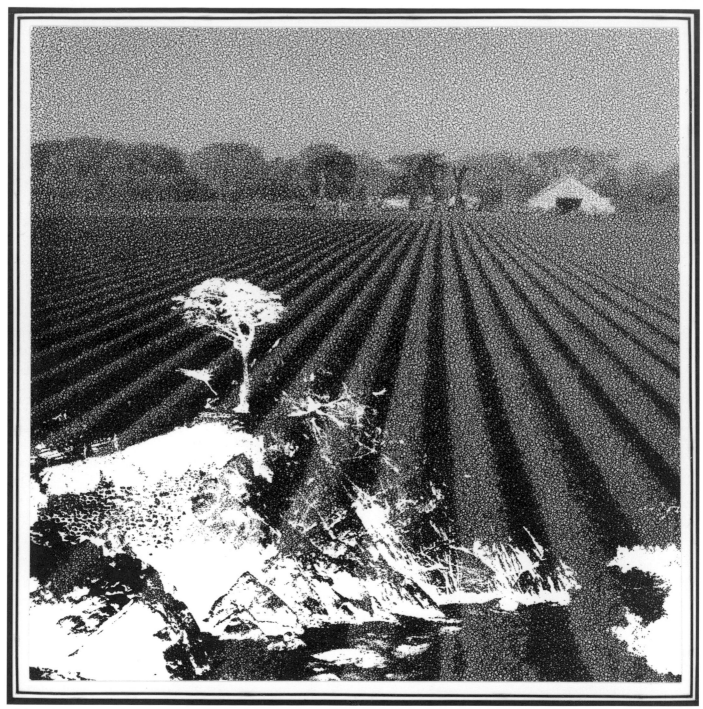

This print was made by combining a black-and-white negative (the farmland) and a color transparency (the lone cypress). They were aligned in the negative carrier (negative sandwiching) and then printed through a screen.

screens are available (such as Mona Lisa, grain, etching, canvas, and others). They can also be made using translucent materials with texture printed over the negative or over the print. Tissue, glass, cloth, wires and netting are all examples. Screens can be printed out of focus, stacked, off-registered or even moved during exposure. Screens can be made from film (like that of tree bark or clouds) and underexposed, or they can be made of other types of film like a litho film.

Combination Printing Uses two or more negatives to make one print. This is accomplished by using one or more enlargers to print multiple images on one sheet of paper, or by sandwiching negatives (placing more than one negative in the negative holder). You must think about how to expose each negative ahead of time.

(Top) Two negatives were placed in the negative carrier and printed normally. One negative was underexposed and the other was normally exposed. This is one way yo achieve a rich black look on a foggy day. (Bottom) This print was made by placing a crab apple blossom in a glass-negative carrier and making a negative print. This negative was then contact printed to make a positive.

There are many variations using this technique, such as:

☐ Off-registering negatives

☐ Cut outs

☐ Dodging a different image into part of a print (like adding clouds)

☐ Using high-contrast negatives without the need for dodging

☐ Combining a photogram and a straight print.

A paper negative is a photographic print which is used as a negative. It is contact printed just as negatives are contact printed for making a contact sheet.

Retouching (by darkening with a pencil or black chalk) can be done on either side of the paper negative to lighten areas in the final print. The positive print can also be retouched, altering contrast locally or overall. You can also retouch on film or matte acetate, instead of the paper negative.

Each generation of the print can be altered by contacting it emulsion to emulsion, or through the paper to get a softened and textured effect from the photographic paper. For a variation, crumple up a dried print and then contact it and perhaps use the Sabattier effect on it.

Printing color negatives/slides will result in positive or negative prints. Negative prints give better shadow details than positives, but usually need more contrast. Maintaining tonal rendition in the reds/blues may require using Kodak Panalure or Ilford Multigrade paper.

A photogram is an image made on photographic paper by placing objects directly on the paper and exposing them to light. You can block out areas to reduce exposure and leave the paper white (or shades of gray). Try making an

I used several techniques to make this print. First a straight print was made. Then I made a 4"x5" overhead transparency of the print using a photo duplication machine. This created a positive that could be printed in a 4"x5" enlarger. It could also be retouched on the emulsion side by darkening it with a lead pencil, or lightened by scratching off the emulsion. From this transparency, a paper negative was made, which could be retouched with potassium ferrocide. Each generation builds contrast, so you may need to reduce the paper contrast grade with such operations. The paper negative was dried and crumpled up. Finally, it was contact printed to make this print. The print shows some distortion and yet retains some appearance of photographic reality.

image with a partial photogram. Print a negative on part of the photographic paper, and on the other part make a photogram.

The Sabattier effect (also called Rayogram) is the reversal of the tones in the print. This can also be done in the negative. Mackie lines,

characteristic of this effect, are light lines between extreme light and dark areas of the print. There are many variations on the process. A basic one follows.

The first exposure is made by contact, preferably from a high-contrast negative or positive, rather than from your original negative or slide. The greater the contrast, the better the definition of the delineation created. Develop just until the images begin to appear. Briefly re-expose by flashing the room light, and continue development for the full recommended time. The areas unaffected by the first exposure will darken in the second development stage. The resulting chemical action will leave clear outlines between all portions of the images (Mackie lines).

The Sabattier effect can be combined with bleaching. Solarization in the print can also result from giving too much exposure to the paper during enlargement.

A partial Sabattier effect occurs when part of the print is covered during the exposure to light. As a result, part of the print will be solarized, creating a tension between the real and the unreal in the photograph.

A photomontage is a multiple image made by combining the images or parts of images. It may be assembled by cutting out pieces of one print and pasting them together with another, in collage fashion, or by making numerous exposures on one piece of printing paper.

A fogged print is a print that turns darker with light before it is fixed.

Photocopy print is a copy of a color print that can be made into a black-and-white print.

The Sabattier effect was used with a special developer to heighten the contrast in the print. The effect can be varied in many ways by changing the developer, exposure times, aperture, development times and dilution. You might try Soligar developer. You might try one cold and one warm developer as well as dodging, burning and bleaching.

Overhead transparencies can be used for contact printing to make negative images.

Torn print is like photomontage, but it is tearing one print and repositioning the pieces, or leaving the tear mark as a part of the image. You might like to re-photograph the torn print so the surface is flat.

Selective development means applying developer unevenly over the print. Straight developer may be splattered on the exposed print from a toothbrush. Or, apply the developer with a squeeze bottle, a brush or cotton. Another approach is to take a final print and draw on it with India ink, then bleach out all, or part of, the image.

Instant materials offer other options. The photographic emulsion transfer (Polaroid's 100 Polapan Type 54) can be removed from its original base to other bases either as a straight image or a distorted one. Prints can be scratched, or the emulsion can be pushed around (with Polaroid's SX-70 Time Zero). These are commonly referred to as manipulated Polaroids. Instant prints can also be spotted, toned, bleached or painted on. If the materials are in color, you can re-photograph them in black-and-white

■ ADDING COLOR

Adding color with single or multiple toners, hand coloring, and monochrome paper are all ways to enhance your black-and-white photographs.

Toners

Toners can change with the paper developer, dilution, content of water, time in toner, amount of washing, age of toner and the mixing of toners. Toners are produced by a number of manufactures, or the photographer may make them.

After this print was made, the black areas were traced over in India ink. When the print was reduced chemically, all the tones disappeared, leaving behind the India ink, which is hard to remove with a reducer. Too much soaking loosens up the bonding of the ink, however, and it will run. To avoid this, don't squeegee the reduced print, and dry it face up. Copying the print and reducing it by about 50% will make the drawing look even better.

Colors range from copper, to iron blue, iron green/blue, yellow, and gold. In many of the newer papers, the anti-stain chemistry in the paper prevents the effect of toning.

Selenium toner makes some prints more neutral than green and darkens blacks. It can also change the color in other ways. Selenium toning can give more permanence to your print, as well as increasing density and contrast, mostly in shadow. It can also eliminate green print color and create a cooler tone.

Combination toning means using more than one toner. The print can be masked with rubber cement or Frisket (a graphic arts product). The exposed area of the print is toned, while the masked area is not. As a result, the print is two-toned.

Hand coloring involves applying color substances to prints. For this to work, the print surface needs to be able to absorb color. You can use food dye, felt-tip pens, pencils, crayons, acrylics, oils or other commercial products.

Printing black-and-white negatives on colored paper offers several approaches. Use one or many filters on one print. Try moving the paper and changing the filter.

Monochrome papers don't have a white base, but instead a colored one—like yellow, red, turquoise, and green.

The photo silkscreen and serigraph process is used with high-contrast film, which is transferred to a special silkscreen film that serves as a mask. Pigment is forced through the screen to make the image. Multiple screens and pigments can be used to add images and color. The result looks like a painted poster. There is a kit (Rockland Silkscreen Emulsion) that will allow you to use conventional darkroom equipment to make cloth stencils without requiring elaborate contact-print equipment and full-size film positives.

■ NON-SILVER GELATIN PROCESSES

While silver gelatin processing is the most common type of photographic printing today, non-silver processes date back to the discovery of the photograph. Their light sensitive emulsion is not silver. Each process has its own characteristic and its own emotional appeal. This section briefly discusses the quality of each non-silver gelatin process. To make the appropriate choice of a non-silver process, you should view examples and have a

working knowledge of the process. The only way to clearly understand the processes and their applications is to work with them.

Papers

A variety of papers can be used with alternative processes. Not all papers work, so they must be tested. There are three current successful papers: Strathmore Artist Drawing #500 Plate; Arches Hot Press Watercolor, and Crane's Kid Finish AS 8111.

Processes

Some of these processes date back to the beginnings of photography. There are many old processes, and some modern adaptations. A few notes are worth considering:

☐ Most of the processes are contact-printed, so you need a negative the same size as the print. An enlarged paper negative can fulfill this requirement.

☐ Negatives for these processes generally need to be more dense than than those used in the silver gelatin process.

☐ Printing usually takes a long exposure, so sunlight or strong artificial light is needed.

☐ The emulsion for these processes is applied to the print surface. Using a brush to do this creates borders with brush marks.

☐ Because many of these processes are old, they can give an "old" appearance to the finished product.

The following are some of the most popular processes. For most, kits are available to make the process simpler.

The platinum and/or palladium process exhibits a very long and delicate tonal scale. Instead of silver, it uses platinum and/or palladium. The image has a matte surface that softens the contrast, making blacks less rich and shadows less apparent. There are more contrast controls with this method than most. Much skill goes into perfecting just the right appearance and luminosity.

Color varies with chemistry and paper sizing, ranging from cool, to neutral, to a warm brown, and even slightly purplish. Toning can change the image color from blue to olive gold or red.

Palladium is currently used alone or with platinum because it is less expensive than platinum and other non-silver processes. It tends to give a more brownish look when used alone. There are kits and pre-coated paper (Palladio) available for this process.

Kallitype has shades of tone which, like the platinum print, exceed that of any resin-coated or fiber-based silver paper. It uses an iron salt (ferric oxalate) as a light-sensitive reducing agent. The image is embedded between the cotton fibers of the paper substrate, but it can be toned to render more stability and archival permanence.

Kallitype has two other advantages over platinum and palladium: The image color can be changed after it is printed and, if it is over-exposed, it can be reduced. Chemical kits are available.

The cyanotype process uses a compound of iron (ferric ammonium citrate and potassium ferrocyanide) rather than silver to form the image. A pale, blue-white image results. Prints can be toned but may be unstable and unpredictable. There may also be some fading with this process. Using a hydrogen peroxide or potassium dichromate oxidizing bath can darken the result.

This process is commonly used for blue prints. There are pre-coated papers available.

The Van Dyke Brown process produces a brown print. It is much like a Kallitype print, except that ferric ammonium citrate is used as the photoactive agent. It is produced as a contact print. For best results, there must be a high range of density on the negative, but there is some contrast control.

> *Each process has its own emotional appeal.*

The carbon process uses light-sensitive sheets of gelatin that contain carbon or other pigments. This print is noted for its subtlety of tonal scale. The results look like a long-scale silver print without signs of the chemical deterioration that might occur in a gelatin print.

No grain can be seen under magnification, but the surface looks speckled with particles of pigment. The surface appears glossy against the light, appearing more in shadows than highlights. The carbon prints might also be colored.

Gum Bichromate is a non-silver process using gum arabic and colored pigments sensitized with bichromate or potassium bichromate. A contact negative is used, and paper is coated with a light sensitive bichromate solution. A variety of items can be used for pigment, such as watercolor, tempera paint, or ceramic stain. Each color or tone is added using separate negatives.

The ambrotype process is a wet plate process that produces a faint negative image on glass. When backed with black, the image looks positive. Ambrotype images look

like a daguerreotype, but do not have a mirror-like surface or change from positive to negative when altering the viewing angle. Such an image is sometimes is called a wet collodion positive on glass.

Photogravure is a printing process that, through mechanical and chemical means, converts the image to be reproduced into tiny depressed dots (intaglio) on a zinc-and-copper print plate. These pits are then filled with ink and a scraper or wiper mechanism removes all of the ink from the surface of the plate. When the plate comes into contact with paper under extreme pressure, the ink transfers to the paper, producing a richly printed image. This process is still used today for high-quality printing, as well as on a smaller scale (sheet-fed gravure) or by printmakers who use etching printing presses.

The salted print process is similar in appearance to the platinum/palladium process but has a delicacy in the lighter tones and flatter shadow tones. It is also less expensive.

There are no kits for this process, so it has to be created from raw chemistry. Prints made with the process look as if the image is embedded in the paper, rather than on the surface as with the silver gelatin process.

Tintype (Parlor) is a process which looks like a tintype. Sensitized emulsion is placed on a metal plate shot inside a camera. Kits are available for 4"x 5" plates.

There are also other less popular processes like bromoil, calotype, carbon, daguerreotype, heliography, oil prints, etc.

As new technologies develop,

This photograph of aspens was printed using the salted print process.

the characteristics of print quality and the techniques used for making prints change constantly.

■ **DISPLAY**

Once the print has been made there are still choices to be made. How will you present it? Consider different ways of mounting and matting your print. There are many types of frames available. What about making and designing your own? There are many familiar ways of arranging and exhibiting prints. What about considering the ceilings or the floors as possible locations? You should also consider lighting.

Mounting and Matting

A print can be mounted on a variety of materials—different ply mat boards, wood, etc.—using dry mount tissue or other adhesive.

A museum mount might place the photograph on the board with photo corners. The print does not always lie flat, but it can be removed for easy storage or when the mat board gets soiled.

The print can be placed on the card in different locations. It can be bordered with lines, drawings or words.

It can be over-matted with a beveled or straight-cut window. The shape of the window might be round, oval, square, rectangular, domed or without a border. The opening can be small or large. There can be several over-mats and fancy cutting, done with a mat cutter or a penknife.

The print can be hung on hooks or floated between glass.

Framing

The frame protects the print from people touching it, and from the natural elements. Framing can also give your print an added attractiveness.

Commercial frames range from fancy wood to metal, and from plastic to paper. When selecting one, consider the overall size, the amount of white you wish to leave around the prints, and the color.

Both glass and Plexiglass® are available for framing purposes. Plexiglass ranges from clear to non-glare and non-scratch. It does not break and is light compared to glass. Glass also has a color cast.

There are numerous other ways to display your prints. Think about displaying your photograph as a positive on film that is backlit, on blocks, on a mobile, or using no frame, as with Swiss clips.

Use your imagination. As with the making of your photographs, be creative.

Exhibiting

When you hang your prints, you can always stick to the traditional gallery or museum handing and spacing.

However, you may also wish to play with the idea of non-traditional spacing and hanging. Try putting photographs on counter tops, making them into large projections, framing them for placement in the garden during a garden party, framing them and leaning them on a shelf or the wall, making placemats out of them, combining them with fabric, putting them on pottery, and so on. You might exhibit stereoscopic images in a viewer mounted to the wall and backlit. You might even exhibit them digitally on Powerpoint®, a popular computer presentation program.

Installation Lighting

Current advances in lighting have made top-quality lighting more affordable, archival and flexible. The right light accentuates a photograph and makes it more readable. It can also enhance a photograph.

Light coverage needs to be even, whether focused narrowly on the print or broadly on the wall. The brightness also needs to be adjustable. Many photographers make their prints specifically to suit the light source, and the light should allow for this.

The design of the fixture itself should not be distracting. Popular types of light fixtures include picture lights (which hang on the frame or the wall), track lights (which are movable fixtures supported by tracks affixed to the ceiling or walls), and recessed lights (which lie flush with the ceiling).

Light can vary in color, evenness, glare and brightness. Daylight-balanced light can allow for more controlled, natural light and avoid the incandescent bulb's warming colors like reds and yellows, and the flattening effect of cool tones like greens and blues. Older fluorescent bulbs do not give an accurate spectrum of light, and they emit ultraviolet rays. Newer fluorescent bulbs have been corrected. Mixing color is now possible. Lights also range from diffused to softened. Louvers can minimize glare.

> *The right light accentuates a photograph.*

Placement of your photographs is important to consider. You should be able to change the display and obtain even lighting with a minimum glare. A general rule of thumb, use about a 30° angle for the lights. Add five degrees for images with large frames.

■ SUMMARY

This chapter starts at the point between pre- and post-visualization. You should learn to previsualize the final print or display before the negative is exposed and the image is created. Once you begin to process your film and print, or begin to display it, you can change your mind. Post-visualization can start anytime after you've exposed the negative.

5

Evaluation and Improvement

What makes a good photograph is ultimately your judgment. In this chapter you will concentrate on developing personal criteria for judging your photographs, developing an artistic statement and formulating a self-criticism. You will look into how to improve the creative decision-making process and identify some of your creative blocks. You will also explore some of the possibilities of digital imaging to help improve your message and print quality.

Make sure your intent is being satisfied.

In addition to these exercises, you need to analyze your own growth continually, visit galleries, read books and periodicals, take lots of photographs and print, print, print.

■ INTENT

Your personal intent and your own criteria should be the standard by which a photograph is judged. Your taste, and the growth of that taste, is paramount to your direction in photography.

Remember your overall intent in selecting photography as an interest. Make sure your intent is being satisfied. Your intent might be to get outdoors in the fresh air. The romance or lore of photography might attract you. The simple but elegant beauty of the print might capture your imagination. You might enjoy working hard and creating a finished, tangible product. You might have a strong desire to communicate or express yourself. There are an endless number of other possible reasons. Maybe you just like it all—the people, the creative freedom, and the enriched vision.

Does it move you as much as music? Or does it capture your imagination? Are you preoccupied with it the way you are "in love" with a boyfriend or girlfriend? It may seem as if nothing can measure up to that passion, but some people's passion for photography is just as intense.

Criticism

Your inner-voice should be heard over the tastes of teachers, friends, clients, other artists and critics. The public's taste and popular trends often breed mediocrity. After all, even the finest critics don't agree. Many viewers tend to see what they want to see. The media tend to sensationalize new technology and movements in art, because their viewers want "newness."

Criticism should challenge you to grow, but in your own direction.

In art there are no rules except those you impose upon yourself. If there were technical or compositional rules for making artistic images, there would be no art, only science.

Your passion and desire to express yourself should motivate your growth in the form of well conceived and executed images.

Guidelines

Be aware of the guidelines, but use them as you see fit. Try new ways of completing the creative decision-making process, and compare them as you build your visual taste. Take time to play and try other media, themes or work—or apprentice yourself with other photographers. Your work may look similar to others because of the close collaboration, but your taste and individuality will make all the difference.

Creative Choices

Most of the creative choices in photography are limited to organization, selection of subject matter and manipulation of the image after the photograph has been made. It is easy to become technically proficient in photography. The challenge is learning how to communicate artistically and creatively.

■ DEVELOPING YOUR PERSONAL CRITERIA

Appraise what you are photographing. Is it good or bad? Creative or not? Emotional or indifferent? Now ask yourself what the reasons are for your evaluation. These reasons are based on personal and/or generally accepted criteria. Prepare a personal list of what you want from photography as a general interest, and what you want your photographs to express or communicate.

The questions posed here are usually answered in the solution stage of the creative decision-making process. They can also become criteria for judging the acceptability of an idea. A possible list of criteria might be:

□ Do all the technical design and creative variables reinforce the theme?

□ Can a 7-year-old understand it?

□ Is it best stated in this medium?

□ Is it romantic?

□ Will it endure?

□ Does it demonstrate your passion or your style?

□ Does it clearly express what you personally saw?

□ Is it clear when you stand back without seeing the detail?

□ Is it mentally understandable and graphically clear?

□ Does it demonstrate good quality?

□ Is it a unique image?

□ Is it accessible and open-ended?

□ Does it have magic?

Challenge each criterion both rationally and emotionally as your visual taste develops.

■ WRITING YOUR ARTIST STATEMENT

Artists are often asked by galleries to write an artistic statement that contains a description of why the artist creates art. It might also contain information on your education, exhibition and award record, as well publications and other activities related to your art.

Artist statements are usually directed at the non-artist and can be used in a gallery exhibit, news articles, resumes, cover letters and even by gallery or museum docents to help explain your work. A reviewer or art critic may also use it in his/her article. Many people are not familiar with art, and an artistic statement is an attempt to help educate and enrich the viewer.

There is a strong school of thought that says artists should not "explain" their work (in this case, their photography). The work itself should be the artist statement and should stand on its own.

It is true that the viewer should not be "told" what to observe. Instead, think of your written statement about your work as another art form that, as mentioned above, enriches the viewer's experience rather than simply explaining it.

Read other artist's statements to stay informed. Note the statements that are particularly clear and that help you understand the work. You may be called upon to explain your work to a viewer in a lecture, or to write articles articulating your beliefs and feelings. In doing this, you will need to make comparisons in styles, symbols, metaphors, movements and techniques. Of course, learning about other art and artists will also help you understand your own work better.

The more realistic a photograph becomes, the harder it may be for the viewer to understand the intent of the photographer's expression. The viewer may not look for meaning in your photograph but may see it simply as a subject or an event. Writing an artistic statement helps to clarify your direction and meaning to a culturally diverse society with different backgrounds, values, ages, beliefs and experiences. Reviewing and revising your statement at various periods is also important. Focus on strong feelings and what you are thinking.

■ SELF-CRITICISM

Criticism is an informed judgment about a piece of work. It is a thoughtful, written or oral discourse that describes, evaluates, interprets (and perhaps theorizes about) the subject. The originator of the work does self-criticism

In self-criticism, approach your work thoughtfully. Your critique should be well thought out and expressed in writing or discussion. It should describe, evaluate, and interpret. It should generally cover

Getting Out of a Rut

You can get in a rut. A good exercise is to write up what you like technically, artistically and expressively. Ask yourself what makes a good photograph. Perhaps you'll want to ask even broader questions, like what the purpose of your photography is?

Take a group of your prints out and analyze what you like or dislike about them. Take reproductions of other artists' work and do the same.

Try doing things differently and spend time appreciating that difference. Feel strongly about what you are doing. Stretch your vision but be guided by your taste.

how the photographer selects or does not select subject matter. Self-criticism places your work in the context of belief, value, attitude, culture, time, vantage point, form, style and both internal and external written material.

Your self-criticism should be more about the image and its visual properties than about you. If the image is to become public, it may develop a life of its own; in which case your other critics will be the photographic community as a whole. Remember that interpretations, including your own, may shift over time.

You can organize your thoughts into the following three categories: description; interpretation and evaluation.

Description

Description denotes the physical content of the subject or event. Try describing the content by answering Who, What, When, Where, Why, How and If ("5W'sH&I," as they say). Another quick way is to use opposites, or poles, to help you quickly describe a print or body of work, as in the following examples:

- □ Is the message "hot" or "cold?"
- □ Realistic or dreamlike?
- □ Non-objective or objective?
- □ Conceptual or non-conceptual?
- □ Formal or informal?
- □ Straight or non-straight?
- □ Happy or sad?
- □ Rich or poor?
- □ Dark or light mood?
- □ High key or low key?
- □ Silhouetted figure or fully-rendered figure?
- □ Out of focus figure or clear figure?
- □ Fulfilled or unfulfilled?
- □ Conscious or unconscious?
- □ Accidental or deliberate?

- □ Visible or invisible?
- □ Clear or obscure?
- □ Control or chaos?
- □ Artificial or natural?
- □ Modernist or postmodernist?

In your descriptive critique, you should identify:

- □ Subject matter (identify and typify persons, objects, places, or events)
- □ Time (period, action or decisive moment)
- □ Vantage point
- □ Artistic elements and properties,
- □ Photographic medium
- □ Style (movement, historical period, geography)

Compare and contrast other photographers' work with your own and examine both internal and external statements as well as the context in which the photograph was made. Basically, describe all the photographic variables of theme, design, choice of camera, film, print and presentation.

Interpretation

Interpretation gives meaning to the physical content. It is what you understand and think. It refers to the point, meaning, sense, tone and mood of the photograph. While description *denotes*, interpretation *connotes*, *suggests* or *implies*. The information in your interpretive critique may come from your stated intent in internal and external sources. Other perspectives might come from the following areas:

- □ Psychological (uses Freudian interpretations)
- □ Marxist (use socialistic views of economic allocation and social class)
- □ Feminist (shows gender equality)
- □ Semiotic ("how" an image means instead of "what" it means, that is, how the image was constructed or how you managed to create the meaning)

Public Criticism

Critics at varying levels of expertise do public criticism. One easy way to learn about critics' views is to read their writings. The following are some periodicals that offer art criticism: *Aperture, Artforum, Art in America, Art Week, Dialogue, Exposure, New Art Examiner, The New York Times, Newsweek*, and *Time*. Read the reviews in these publications critically and note the writers' biases.

Important criticism also comes from curators, historians, museum directors and dealers. Keep in mind that each individual views photography from a different perspective.

- □ Curators select and arrange work for exhibition.
- □ Historians look at it from a historical perspective.
- □ Museum directors may look at artwork from a business viewpoint—will there be a big turnout? Will the viewers like it? They may even try to please their board or benefactors. Museums also make money from promoting artwork, and reproducing it on cards and posters.
- □ Dealers are concerned with art's monetary value.
- □ Galleries have two broadly differing views: a sales gallery mainly handles photographers whose work sells well, while a non-sales gallery (like a museum or art center) hangs more non-traditional works, which may not be intended for sale.

In the world of art criticism, all parties have their unique biases and often a financial slant.

❑ Formalistic (interprets image solely or primarily on considerations of the image's formal properties'—space, light, balance, composition, and framing)

❑ Stylistic (places work in historical and stylistic context: realistic, dream-like, Surrealism)

❑ Biographical (from information about the photographer, relationships of life and images)

❑ Intentionalist (photographer's intent)

❑ Techniques (choice of subject, use of medium, printing methods and so forth)

Evaluation

Evaluation places value and significance on the photograph. That is, whether it is good or bad, graphically strong or weak, and so on. These criteria are generally based on your personal standards, but may also come from a broader theory of what art should be.

A theory is a belief, still held in conjecture, which attempts to define photography, its relation to art, and its purpose. The theories against which you might evaluate a photograph range from realism to instructionalism.

Realism suggests photography should render the beauty of the real or physical world as the eye sees, with the best photographic quality possible and without alteration. The F/64 Group, or "straight" movement, is a good example of realism.

Expressionism dates back to the 1920s (with a revival in the 1970s to present). Important photographers of this style are Walker Evans, Edward Steichen Alfred Stieglitz, and Gertude Kasebier. Heavy emphasis is put on expressing emotions in photography and portraying the inner life.

Pictorialism. Expressing emotions and the inner life are also strong standards in the pictorialism movement. The techniques the pictorialists employed were soft focus, screens, handiwork, collages and retouching with heavy manipulation.

Formalism started in the 20th Century and is closely associated with the modern movement. It holds that art is for art's sake, and the primary subject is abstract form. This theory relies on uniqueness and technical quality, rejecting world concerns, history and psychological and religious themes, and ignoring context.

Instrumentalism is art for life's sake. It relies on themes of social, economic, and moral concerns. It elicits sympathy and has a penchant for the exotic and melodramatic. To an instrumentalist, art is secondary to social concerns.

Pluralism is artwork that is influenced by the criteria used to judge it. Evaluating photographs requires arguments that are informed, convincing and shows insight.

Modernism and Postmodernism are the two strongest theories today.

Modernism is a theory started during the Enlightenment Period, (1687 to 1789). Its tenets are that art should be judged by formalist criteria, showing the purity of medium. There is an emphasis on originality and creative people. It favors black-and-white fine art over commercial photography. It uses symbol over narrative and tends to be realistic rather than instrumental. Its themes are based on democracy, capitalism, science and urbanization.

Postmodernism dates from 1968 to the present and had its origins in Paris. It rejects modernism. It challenges basic writings, or "texts," like the Declaration of Independence for not being achievable. It is skeptical about any ultimate truth and tends to be pessimistic. Postmodern themes are socialism, feminism, anti-modernism, poverty, despotism and ignorance, oppression of workers, imperialism, exclusion of women from the public sphere and the destruction of indigenous people. It appropriates other artwork, including photographs, viewing creativity as a community contribution, not an individual effort. It embraces mass media and believes images can be infinitely reproduced.

> *Evaluation places value and significance...*

The chief contributors to this theory are Jean-François Lyotard, Jacques Derrida, Jacques Lacan, Michel Foucault, and Jean Baudrillard.

Some well-known photographers who hold this approach are John Baldessari, Victor Burgin, Hilla and Bernd Becher, Dan Graham, Sarah Charlesworth, Barbara Kruger, Louise Lawler, Sherrie Levine, Richard Prince, Cindy Sherman, Laurie Simmons and James Welling.

❑ IMPROVING CREATIVITY

The creative problem-solving process is a rudimentary way to understand how people solve problems and create. It is a practice to prepare our thinking about creative problems. It is not necessarily an orderly process, and each step (as discussed in Chapter 1 and summa-

rized here) does not have to be completed. The process is spelled out for you to practice and apply to improving your approach.

The first step is to gather enough understanding and knowledge to see the problem clearly. The next step is to state the problem as clearly as possible. The third step is the idea-finding stage. At this stage, any approach that can help bring out possible photographic solutions is used: guidelines; alternative principles; creative techniques and exercises.

Guidelines and Alternatives

These four guidelines can be applied to all stages in the creative problem-solving process.

1. Avoid criticism of ideas.
2. Encourage wild ideas.
3. Seek a large quantity of ideas.
4. Combine and improve ideas.

In the idea-finding stage, as well as the other stages, you need to list ideas in writing, or record them on tape. Accept any idea; even a duplicate or an idea that has proven unsuccessful should be equally included. The point is to extend this list beyond your normal ideas. Write each idea down as it comes, even if you are not sure it is the solution. Whether the seed of a possible solution, or the actual solution itself, comes to you, you will be enlightened.

Extend this list beyond your normal ideas.

You might try alternating between a group and individual approach. You might also change viewpoints—think of yourself as a zipper, a cannon, or as someone from outer space or from a different period in history. Go back to the problem-finding stage and apply the four guidelines to come up with a new problem statement. Identify one idea as the problem, and go through another idea-finding stage. Try reevaluating your criteria. An otherwise good idea could be deleted if your criteria are too narrow.

Use the four guidelines for determining criteria in evaluating the problem. Help your ideas flow by using some creative techniques, such as checklists and forced relationships. Review and consider the variables of message, camera, design, film, print and presentation. The possibilities are vast.

■ FLUENCY PERIODS

Fluency periods are the times of day or circumstances when ideas flow with ease. Note them. Record them on the Implementation-Finding Worksheet under "Circumstances." This will help you to know when ideas flow. Fluency periods may occur upon waking up, going to sleep, walking slowly, or watering the garden. Perhaps ideas often occur on Sundays just before bed while you are thinking of Monday morning or the pressures of the next week. They may also occur in the shower, when you are preparing for the day. Ideas may occur while reading or printing in the darkroom, that is, during disciplined and repetitive periods. You might find that taking naps helps increase the flow of ideas.

■ CREATIVE TECHNIQUES

Research has identified a number of thought processes that creative people use. These are explained here as six techniques: brainstorm-ing; reverse brainstorming; catalogue technique; checklist technique; free association, and attribute listing.

Brainstorming

This technique uses the four guidelines. A brainstorming session can be a very formal session in which a leader and a recorder are determined. The leader encourages ideas and acts as a referee, blowing the whistle on infractions—such as comments that certain ideas are not appropriate to be listed. The recorder lists ideas for the evaluation or the solution-finding stage.

Alex Osborn originated this technique for use in advertising. Generally, the alternation between the individual (solo brainstorming) and the group (group brainstorming) can be applied to making photographs. A group can be made up of any number and type of individuals. In this setting, hopefully, more and different ideas can be generated.

You might even want to train a group of fellow photographers in the process and meet for dinner, lunch or coffee.

Reverse Brainstorming

This uses the brainstorming technique to criticize a solution or photograph and then suggest new ways of solving a problem or making a photograph.

Sometimes this approach is useful when combined with a brainstorming session. First, list everything wrong with the photograph. Then, systematically review each flaw and suggest ways to overcome it. As an example, take the "Boxed-in Thinking" photograph (page 7) and ask, what is wrong with it?

◻ Not dramatic enough

◻ Needs more action

◻ Needs more depth

◻ Not clear enough without the title

The next step in reverse-brainstorming is to examine each flaw individually and suggest ways the photographer might overcome it. Possible answers might be:

◻ Put subject in the pose of Rodin's "Thinker."

◻ Blur some action.

◻ Put subject in dramatic location, behind the camera on location, in studio under lights, photographing an event.

◻ Make the box smaller or bigger.

◻ Have subject bursting through box.

Catalog Technique

This technique simply refers to the use of various printed catalogs (or other easily-procured sources of printed information) to get ideas that will, in turn, suggest other ideas. As an example, let's continue to think about the "Boxed In" image from page 7. We could use the telephone book yellow pages to find possible ideas from the "Schools" page. Some of these might be:

◻ Make the box look like a graduation cap with a tassel

◻ Make it look like a hard hat

◻ Make the box look like a beauty school graduate with a made-up drawing of a face on the box

◻ Show a diploma on the box or a list of professions

Checklist Technique

Use lists as clues or "leads" for ideas. Check items on a list, such as the ones in this book, against the problem or subject under consideration. Refer to the list of different uses for the flash from Chapter 4 as an example. The objective is to obtain a number of general ideas for further follow-up and development into specific form.

One painter indexes variables on a "Color Wheel," which looks like a lazy susan. It is about 38" high with three different rings. The rings represent subjects, participles and object-configurations of 180 variations—resulting in 5,832,000 possibilities. The painter uses it to make new metaphors and extend the content of his ideas (Judi Freeman. *Mark Tansey*. Chronicle Books, San Francisco, 1993).

For example, use the following checklist, adapted from Alex Osborn's "Magnify, Minify and Rearrange" (Alex Osborn, *Ibid*, pp. 261-289), to come up with your own ideas.

Spurring Questions

OTHER USES—New ways to use as is? Other uses if modified?

ADAPT— What else is like this? What other ideas does this suggest?

MODIFY—Change meaning, color, motion, sound, form, taste, and shape? Other changes?

MAGNIFY—What to add? Greater frequency? Stronger? Larger? Plus ingredient? Multiply?

MINIMIZE—What to subtract? Eliminate? Smaller? Lighter? Slower? Split up? Less frequent?

SUBSTITUTE—Who else instead? What else instead? Other place? Other time?

REARRANGE—Other layout? Other sequence? Change pace?

REVERSE—Opposites? Turn it backward? Turn it upside down? Turn it inside out?

COMBINE—How about a blend, an assortment? Combine purposes? Combine ideas?

Free Association

This technique stimulates the imagination. Jot down a symbol—a word or sketch that is related, in some key way, to an important aspect of the problem or subject under consideration. Jot down another symbol suggested by the first one. Continue jotting down symbols and ad-lib until ideas emerge. Possible answers using the "box" as a symbol might be:

◻ Jail

◻ Psychological illusion of a big person in a small room in a "Mystery House,"

◻ Small world globe, cut through a globe with a person breaking out as if she was breaking out of an egg

Attribute Listing

This is a technique used principally for improving tangible things. An attribute is a quality or characteristic of something.

First, choose some object to improve and study the parts of the object. Next, list the qualities, features, and attributes of both the object and its parts. After you have completed your list, systematically change or modify each attribute.

The objective is to improve the original purpose of the object, or to fulfill a new need with it. If we continue to consider the box, there are many possible solutions:

◻ Make it black

◻ Make it striped like a jail outfit

◻ Make it soft

◻ Make it hard

◻ Make it elastic

◻ Make it huge

◻ Make it small

◻ Make it transparent

◻ Make it transparent, then fill with water and goldfish

◻ Make it transparent, then fill with consumer goods

Forced Relationship

This technique has the same basic purpose as free association, but it attempts to force changes in your photograph by comparing or associating it with another object.

> *Develop new ideas from these patterns.*

First, isolate the elements of the problem at hand. Then find the relationship between these elements. Record the relationships in organized fashion. Next, analyze and record the relationships to find the patterns (or basic ideas) present. Finally, develop new ideas from these patterns.

■ BLOCKS

Remember the quiz in the first chapter and the question about what kept you from listing more ideas? Maybe something (called a creative block) is hindering your free-flow of ideas.

Some common types of creative blocks are listed on page 13. You may identify some of your own creative blocks from this list. Blocks can occur at any point in the creative process, and may vary from problem to problem and from one period of your life to another. As you identify other blocks, add them to the list. The object is to view the creative process with freedom, awareness and playfulness.

The following section gives general examples and possible remedies (one general remedy, and one particularly photographic one).

Perceptual Blocks

1. Your life moves too fast to concentrate on perceiving.

Possible Remedy: Practice slowing down by using the Worksheets.

Possible Photographic Remedy: Make your next photograph while wearing earplugs.

2. You don't give yourself enough time to view your photographs from different viewpoints.

Possible Remedy: Slow yourself down and make a checklist of different viewpoints to go over when making and critiquing a photograph.

Possible Photographic Remedy: Place your head between your legs to view your subject.

3. You are too quick to perceive, stereotype and label.

Possible Remedy: Select two people whose taste you admire and practice looking at your subject with their taste in mind.

Possible Photographic Remedy: Think how photographers with a distinctive view, like Michael Hockney or Witkin, might see the subject.

4. You misjudge your senses.

Possible Remedy: Try double-checking your perception the same way you double check to see if your exposure is correct.

Possible Photographic Remedy: Talk out loud to yourself about what you perceive.

Emotional Blocks

1. You are bound by habit.

Possible Remedy: Identify this block and work at doing the task a different way.

Possible Photographic Remedy: Spend a week photographing a subject you dislike.

2. You are not challenged by new solutions.

Possible Remedy: Think it out. What is the challenge to make new associations?

Possible Photographic Remedy: Spend time printing in a wild way.

3. Your expectations are too high, and fear of failure prevents you from risking new association.

Possible Remedy: Lower your expectations until you are successful and feel happy, and then gradually increase those expectations. Manage your emotions.

Possible Photographic Remedy: Determine a subject that is "silly/stupid" and make and print ten photographs of that subject.

4. You are too sensitive to criticism. Criticism from others can be oppressive.

Possible Remedy: Do not seek or ask for it. Disassociate your photographic work from yourself.

Possible Photographic Remedy: Make a montage from your darkroom waste can and show it to your friends.

5. You are too impatient to tolerate ambiguity or chaos.

Possible Remedy: Focus on your purpose and strengthen it.

Possible Photographic Remedy: Spend a week making photographs as a mad artist, throwing things around with wide abandon.

6. You are a procrastinator who postpones getting started. If it weren't for the last minute, things would not get done.

Possible Remedy: Give yourself false deadlines so that you can enjoy the feeling of being early to finish projects. Break work up into small tasks.

Possible Photographic Remedy: When you get an idea, allow yourself to stop everything and make or sketch a photograph, even if you are in company.

7. You can't start a creative project until you get everything else caught up. Creative projects don't have an end. They go on forever because, if you wait, there may be a better answer.

Possible Remedy: Work in an orderly manner and stay caught up as a general practice.

Possible Photographic Remedy: On two consecutive weekends, put everything else aside until you finish your creative projects. See what happens.

8. You suffer from self-deception.

Possible Remedy: Listen more closely to what people are saying about you or your work.

Possible Photographic Remedy: List all the reasons you are not a famous photographer.

Cultural Blocks

1. People around you reinforce logical thinking and traditional answers.

Possible Remedy: Find friends who reinforce your creative drive.

Possible Photographic Remedy: Take a person of another culture with you next time you photograph and talk about the cultural differences that effect the ways you respond to images.

2. Playing, imagining and fantasizing are frowned upon.

Possible Remedy: Hold steadfast to the advantages of these qualities. Keep quiet. It's your own affair.

Possible Photographic Remedy: Imagine some form of wild art and make photographs like them.

3. Traditional values of success and money are espoused. You could be labeled as a dreamer.

Possible Remedy: Find examples of people you admire and defend yourself with these examples. Stieglitz may have been a dreamer, but we remember his contributions.

Possible Photographic Remedy: Make a series of very commercial landscapes for sale in a gallery and then rest on your laurels.

4. Kidding among friends encourages decisiveness and expected answers.

Possible Remedy: Smile, you know better.

Possible Photographic Remedy: Ask how the kidder might do it.

5. You are pressured to "create" what is expected.

Possible Remedy: It is still good exercise. Use this as exercise for your own creativity. Make the photograph that is expected and do a creative one for yourself.

Possible Photographic Remedy: Make a photograph that is not expected but it is so strong that it is rewarded.

Imaginative Blocks

1. You prefer to criticize rather than come up with ideas.

Possible Remedy: If your training is this way, retrain.

Possible Photographic Remedy: Criticize and then PhotoStorm your criticism, like reverse brainstorming.

2. You don't know how to access imaginative thought.

Possible Remedy: Seek help from those who can, and ask what they do.

Possible Photographic Remedy: Force yourself to photograph in a 3'x3' area.

3. You fear using your unconscious and subconscious.

Possible Remedy: Use these thoughts productively by layering images, weird studio sets, or with a journal.

Possible Photographic Remedy: After a nightly dream, record it and then attempt to make a photograph of it.

4. You think you are fantasizing when you are really being reasonable.

Possible Remedy: Practice being "far out." Expose yourself to different movies, plays and other media.

Digital Imaging

When considering using digital imaging, you need to look at the purpose for your photography.

Despite advances in technology, the chemical-based image can render unique qualities that the digital image cannot. One important difference is technical quality. If the quality available does meet your criteria, you will still need up-to-date programs and equipment (although using a service bureau can satisfy this need).

A digital image can be made by scanning a traditional medium (negative, print, slide, etc.) into the computer from a scanner. It may then be manipulated, then made into a contact negative and printed on photographic paper using the silver gelatin (or another) process. Once the image is scanned, it can be used again to make any size negative. It can also be manipulated using Adobe® Photoshop® or any other image-manipulation software.

If you decide to use a service bureau to output your digital images to prints or film, make sure to calibrate your computer monitor so that the output is the same as that of your service bureau. This will ensure the most accurate, predictable results. Establishing good communication with the staff at your service bureau will also be extremely helpful.

Possible Photographic Remedy: Have your work critiqued by the most outrageous artist you know, and have that person suggest ways he or she might fantasize from your photograph.

5. You don't remember what you have imagined or can't access it when you can use it.

> *Possible Remedy:* Write your ideas down right away. Always have a paper and pencil at hand, and practice capturing your responses.
>
> *Possible Photographic Remedy:* Sketch it.

Intellectual Blocks

1. You don't have enough information to think creatively.

> *Possible Remedy:* Keep asking yourself, "Could I be coming up with more ideas and creative photographs if I knew more about the problem?"
>
> *Possible Photographic Remedy:* Write a narrative essay on one photographic idea.

2. You don't have skills to formulate a problem.

> *Possible Remedy:* Delve deeper into how visual artists express themselves. Study the decision-making process.
>
> *Possible Photographic Remedy:* Discuss with others what you are expressing. Let the words, and hearing yourself express, guide you.

3. You don't have the photographic skills to express yourself.

> *Possible Remedy:* Take a class in photojournalism.
>
> *Possible Photographic Remedy:* Ask people who do, and develop a strong group of friends who are photographers who also do.

4. You don't know how to use the creative problem solving process and have few abilities to complete a solution.

> *Possible Remedy:* Put yourself in a classroom where you have frequent assignments.
>
> *Possible Photographic Remedy:* Put yourself under pressure to complete your work. Seek exhibits or places

to show your work, hang it in your own home, make a portfolio to show friends.

5. You can't reason from another viewpoint.

> *Possible Remedy:* Pick a photographer who has a strong, distinct vision and use that as a different viewpoint.
>
> *Possible Photographic Remedy:* Use a Wratten 90 filter to remove color.

6. You place little importance on using your intellectual skills for creativity. Change for change's sake is wasteful.

> *Possible Remedy:* Read biographies of important people to see the importance creativity plays in their lives.
>
> *Possible Photographic Remedy:* Identify a photograph of your location and create a new one. Note how newness attracts change.

Expressive Blocks

1. You have inadequate visual and photographic skills to express or communicate a message. Coming up with a creative solution is hard work.

> *Possible Remedy:* Narrow your interest and become more proficient.
>
> *Possible Photographic Remedy:* Take a workshop in a new photographic subject.

2. You are not quick enough to capture the subject.

> *Possible Remedy:* Find out how others do it and practice.
>
> *Possible Photographic Remedy:* Practice photographing children.

3. You don't care to express yourself.

> *Possible Remedy:* Ask yourself, "Does expressing an experience lead to a richer understanding of that experience, and does that make your life fuller?" Or maybe you just need to avoid being lazy.

Possible Photographic Remedy: With a group of photographic friends, give yourselves an assignment and use your peers to force you to express yourself.

4. You don't allow enough time to finish making a creative photograph.

> *Possible Remedy:* Give yourself twice as much time to finish something, or allow yourself more time to photograph when making appointments.
>
> *Possible Photographic Remedy:* Never think of your "final" print as the last print. Allow enough time for a second final print. Spend time looking at your first final print.

5. Your ability grows slower than your taste. As your taste matures, it is harder to satisfy.

> *Possible Remedy:* Re-evaluate your direction, take a workshop.
>
> *Possible Photographic Remedy:* Take a workshop or class in some artistic endeavor you know little about.

Environmental Blocks

1. Your friends and acquaintances consider creativity a low priority.

> *Possibly Remedy:* Be around more creative types of people.
>
> *Possible Photographic Remedy:* Be confrontational.

2. You are distracted by noise, intrusions, other thoughts of a competitive nature or everyday pressures and a fast-paced activity.

> *Possible Remedy:* Settle down, learn to concentrate and give yourself goals. Keep reinforcing them by stressing their importance.
>
> *Possible Photographic Remedy:* Practice working as a photojournalist.

3. You have so many "more important" things on your to-do list that you put aside creative problems.

> *Possible Remedy:* Work harder for yourself than others. Your preparation in

school is more for you and living than for work.

Possible Photographic Remedy: Plan a specific time for some regular photographic activity.

4. You are too fidgety and can't settle down.

Possible Remedy: Seek calmer activities and challenge yourself to understand things more deeply.

Possible Photographic Remedy: Make a plan doing "fidgety" or easier things first in photography, and then proceed to areas of higher discipline.

◼ SUMMARY

There are things that motivate and things that distract you from being more creative.

Creativity in art is usually a means, not an end.

Motivators make you want to become more creative. Some motivators include:

◻ Using tools and ideas in a playful mood to get to a greater depth.

◻ Striving puts ideas into reality. Creativity put ideas into form.

◻ Making an effort to communicate and to enrich your individual/unique expression.

◻ Striving for growth, not just for newness for newness' sake.

◻ Gaining satisfaction from an inner reward for its own sake.

◻ Practicing your creative ability regularly.

Distractors prevent or slow your desire to create. Some distractors include:

◻ An inner voice that is not as strong as others' evaluation (such as teachers, family members or friends).

◻ Misdirected praise or celebrity status for success that stems from self-importance rather than from creativity.

◻ Using financial gain as a motivator for, or measure of, your success.

◻ Taking your work too seriously.

◻ Working under deadline pressure and not leaving enough time for the implement stage.

◻ Judging ideas before they are thought out.

◻ Setting your expectations too high.

◻ Considering too few ideas and directions in all the creative problem-solving stages.

PhotoStorming takes the fundamentals of a knowledge of creativity and applies them to all the choices or variables in photographic expression. Work with the four variables: theme; artistic elements; photographic variables, and creative principles and activities.

> *Mold your choices around your tastes and experiences.*

Continue to assimilate them into your way of making photographs. Mold your choices around your tastes and experiences. Revisit PhotoStorming for an occasional refresher. Keep practicing and expanding your creative ability.

6

Exercises and Self-Assignments

■ INTRODUCTION

The first chapter of this book discussed a creative approach to making photographs. Each decision was outlined and you were instructed to consider each of these variables when making a creative photograph. Now that you have familiarized yourself with these variables, you need to play with the possibilities they represent and use them to generate more ideas when making a photograph.

This chapter presents exercises designed to help you use these variables in your own creative process.

At first, you might find it easier to work with an existing photograph rather than to start the creative process from scratch. There is a photograph for each exercise demonstrating a variety of subject areas: landscape; portrait; architecture; still life, and automobile. Bounce ideas off this photograph, or use one of your own.

You might like to use the "Idea-Finding Form" and the "Implementation Form" to help you start your creative process. Follow the instructions for each exercise and use the space provided for your answers. Remember, creativity is hard work and a disciplined endeavor. The three most important ways to be creative are practice, practice, and practice.

> *Creativity is hard work and a disciplined endeavor.*

The exercises following the worksheets are adapted from Marvin Small's book entitled *How to Make More Money* (Pocket Books, N.Y., 1955).

PROBLEM- AND IDEA-FINDING WORKSHEET

After you have determined the facts and information you need to clearly understand the visual requirements of the photograph—thoughts, techniques, composition, meaning and so on—you are ready to start the problem-finding stage

Start by questioning, defining, and redefining what it is you are trying to solve. "In what way might I photo-graph...?", or "How might I change or improve...?" Start with a fuzzy idea of a photograph. Narrow it down as you work through the problem-finding stage until you are satisfied with one problem. This will be the problem statement.

The problem statement should ask for possible answers that solve the problem. Refer to Chapter One for more details.

Once you arrive at the problem, list as many ideas as possible in the idea-finding stage. Use the guidelines, the alternative principles, creative techniques and exercises. Also try sketching it, then describing and titling the sketch. Use extra sheets if necessary.

Problem-Finding:

Idea-Finding:

DESCRIPTION	SKETCHES	TITLE

SOLUTION-FINDING WORKSHEET

List all the ideas that have possibilities from the "Idea-Finding Worksheet." Go back and forth. Next fill out the specific criteria for this photograph (or series) and the general criteria. You can rank the ideas using numbers against the criteria. (1-Excellent, 2-Good, 3-Average, 4) Poor and 5) do not pertain. This method usually weights one alternative over the other. Chances are, with a creative solution, you will go through this worksheet and the answer will present itself. These criteria then act as a checklist.

SPECIFIC CRITERIA: **GENERAL CRITERIA:**

IDEAS:

1.								
2.								
3.								
4.								
5.								
6.								
7.								
8.								
9.								
10.								
11.								
12.								
13.								
14.								

IMPLEMENTATION-FINDING WORKSHEET

Start with the "Problem- and Idea-Finding Worksheet" if you have a general idea but no strong image. If you already have a strong idea, start here and then use the "Idea-Finding Worksheet" on the other side of this page. Go back and forth. This sheet clarifies all details required to make the photograph. It acts as a memory aid and it forces you to think about making the photograph in real terms.

Title: _____

Color, B&W, or Other: _____

Shooting Date: _____

Weather: _____

Shooting Time: _____

Location: _____

Circumstances--Idea Date: _____

Place: _____

Sketch/Work Print/Instant Print:

Description (effect, expression, light, graphic impact, emotion, content, etc.):

Technical (print quality, size, lighting, film, filter, possible problems, etc.):

Props and supplies:

What other photographs might be made at this time?

Misc. (permits, releases, clearances):

■ EXERCISE 1—QUICK PHOTOSTORMING

Consider how the mind, eye and camera see the photograph. "The mind" is the intellectual intent of the photograph. "The eye" is how you see the subject. "The camera" is how the idea is expressed photographically.

This exercise is a quick way to use PhotoStorming. Simply list suggestions for changing this or any other photograph using the following questions to suggest answers. Remember to use the creative guidelines and the alternative principles in Chapter One.

Read the questions, then use the space provided to jot down your own answers about the photograph you are considering. You may wish to photocopy these pages rather than writing directly in the book.

1. "The mind" is what you think about the photograph.

❑ How might one change/improve the photograph's statement?

❑ What does the photography say, express, or communicate? To whom? What? When? Where? Why? How?

Your ideas on the photograph's statement:

❑ How might one change/improve the photograph's statement to the audience?

❑ What might be the viewers' age, education, background, and general type?

Your ideas on the photograph's statement to the audience:

Additional notes:

2. "The eye" is what you see.

❑ How might one change/improve the photograph's FORMAT?

❑ Consider size and viewing distance, eye movement, general impression and photo shape.

Your ideas on format:

❑ How might one change/improve the spot or dominant feature in the work?

❑ Consider the shape of the spot or visual line, and whether it is disturbing.

Your ideas on the spot or dominant feature of the photograph:

❑ How might one change/improve the line or route the eye travels?

❑ Consider horizontal, vertical, oblique, irregular or contrasting lines that make up visual shapes.

Your ideas on the line or the route the eye travels:

Sample photograph for Exercise 1.

❑ How might one change/improve the volume in the photograph?

❑ Consider triangle, circle, square, rectangle, irregular volume and contrasting volume.

Your ideas on the volume in the photograph:

◻ How might one change/improve the photograph's contrast?

◻ Consider spot, line, volume, spatial distribution, sizes, numbers, sharpness and movement.

Your ideas on the photograph's contrast:

Additional notes:

3. "The camera" is what the photographer renders.

◻ How might one change/improve the film?

◻ Consider speed, grain, contrast, size, type, resolving power, forms and any film related problems.

Your ideas on film:

◻ How might one change/improve the camera?

◻ Consider the type, lens, shutter setting, aperture setting, multiple exposure, special features, filters and attachments.

Your ideas on the camera:

◻ How might one change/ improve the print?

◻ Consider the process, enlarger, manipulation, developer, paper, cropping, filters and display.

Your ideas on improving the print:

Additional notes:

■ EXERCISE 2—ARTISTIC PHOTOSTORMING

This exercise associates the artistic elements, properties and compositional features of a photograph.

Use the artistic or design elements in PhotoStorming to find as many possible changes or improvements in this photograph or any other you choose.

Simply list suggestions for changing this or any other photograph using the following questions to suggest answers.

Remember to use the creative guidelines and the alternative principles in Chapter One.

Read the questions. Then use the space provided after each one to jot down your own personal answers about the photograph you are considering.

1. Elements are ingredients that must exist in a photograph.

☐ How might one change/improve the surface, mass and subject of the photograph?

☐ How might one change/improve the position, pattern and volume of the photograph?

☐ How might one change/improve the line, tone, edge, and rhythm of the photograph?

Your ideas on the photograph's:
Surface:

Sample photograph for Exercise 2.

_____ _____ _____

_____ _____ _____

_____ _____ _____

Mass: *Volume:* *Rhythm:*

_____ _____ _____

_____ _____ _____

_____ _____ _____

_____ _____ _____

_____ _____ _____

Subject: *Line:* *Notes:*

_____ _____ _____

_____ _____ _____

_____ _____ _____

_____ _____ _____

_____ _____ _____

Position: *Tone:*

_____ _____

2. Properties are ingredients that exist but don't have to be present.

 ☐ How might I change or improve the completeness of image or picture?

_____ _____

 ☐ How might I change or improve tone, texture, depth, and motion?

_____ _____

 ☐ How might I change or improve balance, unity, clarity, and dominance?

_____ _____

Pattern: *Edge:* Your ideas on photograph's:
Completeness:

_____ _____ _____

_____ _____ _____

Tone:

Texture:

Depth:

Motion:

Balance:

Unity:

Clarity:

Dominance:

Notes:

3. Composition is the arrangement of elements and properties.

◻ How might one change/improve the photograph by static composition (where ingredients appear at rest)?

◻ How might one change/improve the photograph by symmetry in composition (where the photograph can be equally divided)?

◻ How might one change/improve the photograph with central composition (where the eye is drawn to the center)?

◻ How might one change/improve the photograph with dynamic composition (where the subject is tilting, or the lines are diagonal)?

Your ideas on the photograph's:
Composition:

Symmetry:

Central composition:

Dynamic composition:

Notes:

■ EXERCISE 3—PHOTOGRAPHIC PHOTOSTORMING

This exercise uses the photographic variables in Photostorming. These are: film; camera, and print. Refer to the photograph below or use one of your own. Read the questions and the sample answers, then use the space provided to jot down your own suggestions. Using the photograph below, make as many changes/improvements as you can. Alternately, you may wish to select another photograph to PhotoStorm. Whatever your choice, remember to use the creative guidelines and the alternative principles discussed in Chapter One.

1. How might one change/improve the film?

Examples:

Speed: Slow to ultra fast. Push development.

Grain: Medium to extremely fine.

Contrast: Moderately low to ultra high.

Size: 35mm, 120, 4 x 5, and others.

Type: Black-and-white, color, positive, negative, instant, infrared, high contrast, recording and litho.

Resolving Power: Moderately low to ultra high.

Forms: Sheets, rolls and packs.

Special Features: Reticulation and others.

Your ideas on:
Speed:

Sample photograph for Exercise 3.

Grain:

Contrast :

Size:

Type:

Resolving:

Power:

Forms:

Special features:

Additional notes:

2. How might one change/improve the camera?

Examples:

Type: Range finder, single-lens reflex, twin-lens reflex or view.

Lens: Angle of view, sharpness, distortion control and special effects (such as a zoom effect).

Shutter: Motion control and exposure.

Aperture: Sharpness and depth of field.

Multiple exposure: Multiple number of times, with/out flash movement.

Special features: Self-timers, winder, motor drive, automatic exposure and others.

Filters: Black-and-white correction, contrast, reducing haze, polarizing screens and neutral density, special, multiple exposures, and split-field.

Attachments: Transmission diffraction, soft-focus effects, vignetting, cross-screen, multiple-image lenses, fish-eye effects, split-field effects, close-up and telephoto attachments, electronic flash.

Your ideas on:
Type:

Lens:

Shutter:

Aperture:

Multiple exposure:

Special features

Filters:

Attachments:

Notes:

3. How might one change/improve the print?

Examples:

Process: Silver—gelatin, salted paper and Ambrotype; Ferric—Cyanotype, platinum, palladium, and Kallitype; Dichromate—carbon, carbro, gum printing, oil and bromoil; Polaroid transfer and image transfer; Photomechanical—photogravure and collotype; Photo-copy and mixed media.

Enlarger: Condenser, diffusion, and point source.

Manipulation (mechanical, chemical, and computer): Cropping, selective contrast, combination printing, screens, diffusion, flashing, distortion control, high contrast, Sabattier, posterization, photogram, split filtering, negative intensification, paper negative, torn print, bleaching, hand coloring, and combination.

Developer: Split, soft, sharp, hard, rich black, and others.

Paper: Image tone, paper tint, brilliance, contrast, color, texture and weight.

Cropping: Circle, arch, square, rectangle, spherical shape, and others.

Filters: Contrast, diffusion and masks.

Toners: Selenium, gold, sepia, blue, Polytoner, and others.

Display: Mat, over-mat, sequence mounting, museum mount, frame, and others.

Your ideas on:
Process:

Enlarger:

Manipulation:

Developer:

Paper:

Cropping:

Filters:

Toners:

Display:

Notes:

■ EXERCISE 4—PhotoStorming Solitaire

This exercise explores the artistic or design elements in Photostorming. Using them, suggest changes or improvements in the photograph on the opposite page (or any other you choose).

Simply list your suggestions using the following questions to suggest answers. Remember to use the creative guidelines and the alternative principles in Chapter One. Read the questions, then use the space provided to jot down your own answers about the photograph you are considering.

These variables are fairly complete for considering the photographic image. You should interrelate them—that is, use items from each of the five categories. Consider these together to force yourself to relate ideas. For example, the human condition (message), add light (scene), fine grain (film), 35mm camera (camera), and silver print (print).

1. The message is what the viewer derives from the photograph.

Examples of message variables:
- ☐ Love
- ☐ Light and Dark
- ☐ Parody
- ☐ Photo as art object
- ☐ Beauty
- ☐ Photo as poem
- ☐ Concern of people for animals
- ☐ Commentary on the human condition
- ☐ Reverence
- ☐ Nostalgia
- ☐ State of mind
- ☐ Narrative Surrealism
- ☐ Sympathy
- ☐ Humor or satire
- ☐ Conflict
- ☐ Achievement
- ☐ People in action scenes

Your ideas on the message:

2. The scene is the real image in the photograph.

Examples of scene variables:
- ☐ Subject(s)
- ☐ Background
- ☐ Artificial light
- ☐ Season
- ☐ Time of day
- ☐ Special condition
- ☐ Properties and composition
- ☐ Natural light
- ☐ Arrangement and rearrangement
- ☐ Props and models
- ☐ Artistic elements

Your ideas on the scene:

3. The film is what the image is recorded on.

Examples of film variables:
- ☐ Speed
- ☐ Problems
- ☐ Size
- ☐ Contrast
- ☐ Grain
- ☐ Resolving power
- ☐ Type
- ☐ Forms

Your ideas on the film:

4. The camera is the machine that records the image.

Examples of camera variables:
- ☐ Type
- ☐ Filters

Sample photograph for Exercise 3.

☐ Aperture setting
☐ Shutter setting
☐ Lens
☐ Special features
☐ Multiple exposure
☐ Attachments

Your ideas on the camera:

5. The print is how the final image is displayed.

Examples:

☐ Process
☐ Filters
☐ Manipulation
☐ Developer
☐ Enlarger
☐ Cropping
☐ Paper
☐ Display

Your ideas on the print: *Notes:*

_____ _____

_____ _____

_____ _____

_____ _____

_____ _____

_____ _____

_____ _____

_____ _____

_____ _____

■ EXERCISE 5—FANTASY PHOTOSTORMING

Variables consist of the purpose for shooting photos, the unique way the camera sees, and fantasies.

This exercise will encourage you to come up with wilder ideas. Make as many changes or improvements as possible in the photograph below (or any other you choose). Simply list suggestions for changing this or any other photograph using the following questions to suggest answers. Remember to use the creative guidelines and the alternative principles in Chapter One.

Read the questions, then use the space provided to jot down your own answers about the photograph you are considering.

1. Purposes are the reasons to photograph.

Examples:

For Cause—to express, communicate, satisfy ego, entertain, change, sell, deceive, improve craft, realize talent, grow, make social comment.

For Enlightenment—to be artistic, poetic, dream or fantasize, grow

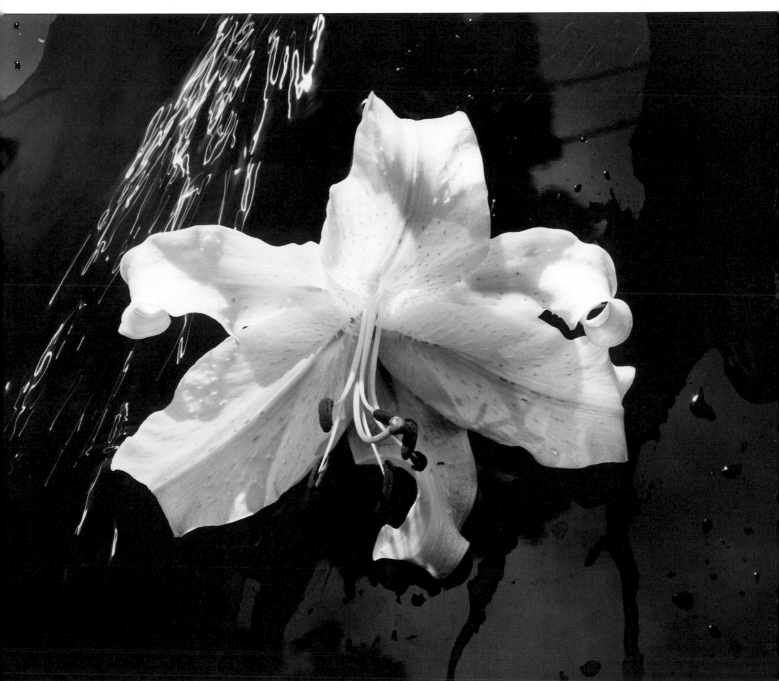

Sample photograph for Exercise 5.

or expand, become aware, illuminate, pleasure, play, create beauty, reveal what also is, symbolize, and express self.

For Study—Descriptive, explanatory, interpretive, ethically evaluative, aesthetically evaluative and theoretical.

Your ideas on:
Cause:

Enlightenment:

Study:

Notes:

2. Photographic uniqueness describes the way that a camera can see, but that the human eye can't.

Examples:

Camera: Movement, format, filters and special attachments and flash

Lens: Angle of view, varying apertures, zoom effect, perspective

control, wide-angle distortion and long-lens compression.

Film: Type, scale, contrast range, storing light, special processes.

Print: Illusions of depth, texture, reality, motion, special print effects, processes and techniques.

Combinations: Multiple images.

Your ideas on:
Camera:

Lens:

Film:

Print:

Combinations:

Notes:

3. Fantasies are unrestrained imagination.

Examples:
- ☐ Nightmares
- ☐ Magic
- ☐ Superhuman abilities
- ☐ Extravagance
- ☐ Heaven or hell
- ☐ Poverty
- ☐ Unusual Qualities
- ☐ Control of others
- ☐ Different genders
- ☐ Living in different periods of time
- ☐ Far-away places
- ☐ Excursions
- ☐ Success
- ☐ Failure
- ☐ Self-deception

Your ideas on:
Fantasies:

Notes:

■ EXERCISE 6—CHECKLIST PHOTOSTORMING

Checklists are based on the philosophy that creative ideas are new combinations of previously unrelated elements. The technique involves checking items on a prepared list against the problem, message, or topic being explored. The goal is to generate a number of general ideas which can be followed-up and developed into a specific form.

Using the photograph provided below (or any photograph you select), make as many changes or improvements as you can. List your suggestions, using the following questions to suggest answers. Some of the items may not be relevant to all photographs. Suggestions are provided to help you get started. Remember to use the creative guidelines and the alternative principles in Chapter One.

1. Can the dimensions be changed?

Examples:
- ☐ Enlarge
- ☐ Place horizontally
- ☐ Make crosswise (bias, counter)
- ☐ Thicken
- ☐ Invert (reverse)
- ☐ Converge
- ☐ Stand vertically
- ☐ Lengthen
- ☐ Encircle
- ☐ Stratify
- ☐ Deepen
- ☐ Make smaller
- ☐ Make slanted or parallel
- ☐ Delineate
- ☐ Make shallower
- ☐ Shorten
- ☐ Border
- ☐ Make thinner

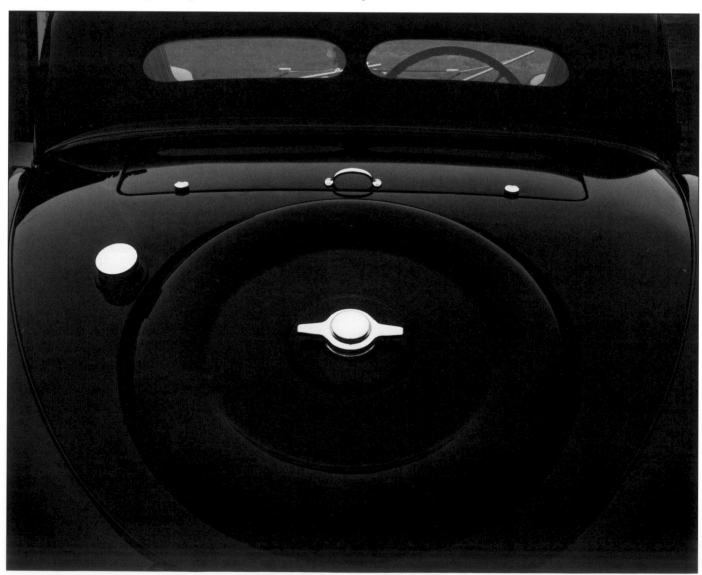

Sample photograph for Exercise 6.

Your ideas on dimension:

2. Can the quantity be changed?

Examples:
- ☐ Add more
- ☐ Add something
- ☐ Change proportions
- ☐ Join something
- ☐ Complete
- ☐ Combine with something else
- ☐ Divide
- ☐ Delete something

Your ideas on quantity:

3. Can the order be changed?

Examples:
- ☐ Arrangement
- ☐ Precedence
- ☐ Assembly or disassembly
- ☐ Beginning
- ☐ Focus

Your ideas on order:

4. Can the time element be changed?

Examples:
- ☐ Faster
- ☐ Synchronized
- ☐ Perpetuated
- ☐ Longer
- ☐ Slower
- ☐ Anticipated
- ☐ Chronologized
- ☐ Shorter
- ☐ Renewed

Your ideas on time:

5. Can the cause or effect be changed?

Examples:
- ☐ Stimulated
- ☐ Destroyed
- ☐ Altered
- ☐ Strengthened
- ☐ Energized
- ☐ Softer
- ☐ Louder
- ☐ Counteracted

Your ideas on cause or effect:

6. Can there be a change in character?

Examples:
- ☐ Stronger
- ☐ Cheaper
- ☐ Interchanged

☐ Uniformity
☐ Converted
☐ Resilient
☐ Altered
☐ Substituted
☐ Stabilized
☐ Change color
☐ Reversed
☐ More expensive
☐ Weaker
☐ Add color

Your ideas on character:

7. Can the form be changed?

Examples:

☐ Regular
☐ Rougher
☐ Delays
☐ Straight
☐ Smoother
☐ Symmetrical
☐ Notched
☐ Curved
☐ Accidents
☐ Something added
☐ Softer
☐ Conformation
☐ Irregular
☐ Avoided

☐ Harder
☐ Prevented

Your ideas on form:

8. Can the motion be changed?

Examples:

☐ Animated
☐ Deviated
☐ Lifted
☐ Stilled
☐ Attracted
☐ Lowered
☐ Accelerated
☐ Repelled
☐ Rotated
☐ Slowed
☐ Admitted
☐ Oscillated
☐ Directed
☐ Barred
☐ Agitated

Your ideas on motion:

9. Can the state or condition be changed?

Examples:

☐ Hotter
☐ Parted
☐ Insulated
☐ Softened
☐ Solidified
☐ Pulverized
☐ Opened or Closed
☐ Liquefied
☐ Wetter
☐ Performed
☐ Abraded
☐ Elasticized
☐ Colder
☐ Effervesced
☐ Heavier
☐ Hardened
☐ Vaporized
☐ Resistant
☐ Disposable
☐ Lubricated
☐ Drier
☐ Incorporated
☐ Coagulated
☐ Lighter

Your ideas on state or condition:

Notes:

10. Can the use be adapted to a new subject?

Examples:

☐ Men

☐ Children

☐ Handicapped

☐ Women

☐ Old

☐ Foreign

Your ideas on adapting to a new sub-ject:

■ EXERCISE 7—SUPREME PHOTOSTORMING

This exercise uses all the photographic variables in this book. Take any of your photographs and play with changing them using the following ideas.

As a review, you may wish to list each of the possible variables under each of the following categories. Each different possibility is discussed earlier in the text. Add to this list any variables you might like. Evaluate it later.

1. Theme variables

Your ideas:

2. Design variables

Your ideas:

3. Camera variables

Your ideas:

4. Printing variables

Your ideas:

5. Film variables

Your ideas:

6. Display variables

Your ideas:

Additional Resources

■ BOOKS

The following books will provide instruction on the subjects mentioned in this book.

Basic Textbooks

Alesse, Craig. *Basic 35mm Photo Guide*. (Amherst Media, Inc.: Buffalo, NY) 2000.

Davis, Phil. *Photography, 7th ed.* (Brown & Benchmark: Dubuque, IA) 1994.

London, Barbara and John Upton. *Photography, 6th ed.* (Addison-Wesley Education Pub, Inc.: New York, NY) 1997.

Schaefer, John P. *Basic Techniques of Photography* (Little, Brown and Company: Boston, MA), 1998.

Theme

Geibert, Ron. *Photography in the 1990s*. (WSU Art Galleries: Dayton, OH) 1996. Note: A CD-ROM portfolio of fifty artists with work and statements.

Carothers, Steven and Gail Roberts. *Photographer's Dialogue* (Social Issues Resources Series, Inc.: Boca Raton FL), 1988.

Design

Croy, O.R. *Design by Photography*. (Hastings House Publishers, Inc.: New York, NY) 1972. Also *Graphic Effects by Photography*.

Dunn, Charles. *Conversations in Paint: a notebook of fundamentals*. (Workman Publishing: New York, NY), 1995.

Camera

Adams, Ansel. *Examples* (Little, Brown and Company: Boston, MA) 1983. Note: Good practical description of black-and-white filter usage.

Eastman Kodak Co. *Kodak Photographic Filter Handbook* (Eastman Kodak Co.: Rochester, NY) 1996.

Lefkowitz, Lester. *Electronic Flash: A Kodak Workshop Series* (Eastman Kodak Co.: Rochester, NY) 1986.

Shull, Jim. *Beginner's Guide to Pinhole Photography* (Amherst Media, Inc: Buffalo, NY) 1999. Note: How to make and use pinhole camera.

Film

Burkholder, Dan. *Making Digital Negatives* (Bladed Iris: San Antonio) 1998. Note: Making computer-enlarged negative for silver and alternative processes.

Paduano, Joseph. *The Art of Infrared Photography, 4th ed.* (Amherst Media, Inc.: Buffalo, NY) 1998.

White, Laurie. *Infrared Photography Handbook*. (Amherst Media, Inc.: Buffalo, NY) 1995.

Printing

Anchell, Stephen. *The Darkroom Cookbook* (Stephen Anchell) 1994. Note: Recipes for developers, stop, fix, toners and others.

Eastman Kodak Co. *Creative Darkroom Techniques*. (Eastman Kodak Co.: Rochester, NY) 1973. Note: Special printing techniques

Graves, Carson. *The Elements of Black & White Printing* (Focal Press: Boston, MA) 1993.

Nettles, Bea. *Breaking the Rules: A Photo Media Cookbook* (Inky Press Productions: Urbana, IL) 1992. Notes: A basic alternative process textbook.

Display

Smith, Lawrence B. *The Art of Displaying Art* (The Consultant Press: New York, NY) 1997. Notes: A simple approach to display.

■ MAGAZINES

American Photo
Camera Arts
Lenswork Quarterly
Photo Techniques
View Camera

■ SUPPLIERS

For all of your photographic needs, check with your local camera store or photography supply house. They will be able to answer your questions, provide suggestions and order any equipment or supplies you might want. For specialized needs, you may wish to contact one of the companies listed below.

Exposures
P.O. Box 3615
Oshkosh, WI 54903-36151
800-572-5750
Supplier of frames, albums, displays and archivally safe products.

Photographers' Formulary
P.O. Box 950
Condon, MT 59826
800-922-5255
www.montana.com/formulary
Alternative processing kits and raw chemistry.

Bostick and Sullivan
P.O. Box 2155
Van Nuys, CA 91404
818-785-4130
Materials related to platinum and palladium printing.

Light Impressions
P. O. Box 940
Rochester, NY 14603-0940
800-828-6216
Archival materials.

University Products, Inc.
517 Main Street
P.O. Box 101
Holyoke, MA 01041-0101
800-628-1912
Archival paper products.

■ WEB SITES

Remember, the Internet is still a volatile source of information.

Freestyle Alternative Process:
 www.freestylesalesco.com/
 altprocess.html

Alternative Process FAQ:
 www.Duke.suask.ca/~holtsg/
 photo/faq.html

Pinhole Camera Resource:
 www.pinholeresource.com

View Camera Magazine:
 www.viewcamera.com

Kodak:
 www.eastman.org

Polaroid:
 www.polaroid.com

U-Turn (an electronic journal of photography and criticism):
 www.uturn.org

Center for Creative Photography (Tucson, AZ):
 www.ccp.arizona.edu/ccp.html

Agfa Products & Services:
 www.agfanet.com

Fuji:
 www.fuji.com

Photo-Eye Books & Prints:
 www.photoeye.com

Index

Other Books from
Amherst Media™

Basic 35mm Photo Guide

Craig Alesse

Great for beginning photographers! Designed to teach 35mm basics step-by-step — completely illustrated. Features the latest cameras. Includes: 35mm automatic, semi-automatic cameras, camera handling, *f*-stops, shutter speeds, and more! $12.95 list, 9x8, 112p, 178 photos, order no. 1051.

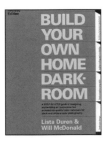

Build Your Own Home Darkroom

Lista Duren & Will McDonald

This classic book teaches you how to build a high quality, inexpensive darkroom in your basement, spare room, or almost anywhere. Includes valuable information on: darkroom design, woodworking, tools, and more! $17.95 list, 8½x11, 160p, order no. 1092.

Into Your Darkroom Step-by-Step

Dennis P. Curtin

This is the ideal beginning darkroom guide. Easy to follow and fully illustrated each step of the way. Includes information on: the equipment you'll need, set-up, making proof sheets and much more! $17.95 list, 8½x11, 90p, hundreds of photos, order no. 1093.

Wedding Photographer's Handbook

Robert and Sheila Hurth

A complete step-by-step guide to succeeding in the world of wedding photography. Packed with shooting tips, equipment lists, must-get photo lists, business strategies, and much more! $24.95 list, 8½x11, 176p, index, b&w and color photos, diagrams, order no. 1485.

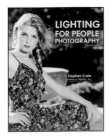

Lighting for People Photography, 2nd ed.

Stephen Crain

The up-to-date guide to lighting. Includes: set-ups, equipment information, strobe and natural lighting, and much more! Features diagrams, illustrations, and exercises for practicing the techniques discussed in each chapter. $29.95 list, 8½x11, 120p, b&w and color photos, glossary, index, order no. 1296.

Outdoor and Location Portrait Photography

Jeff Smith

Learn how to work with natural light, select locations, and make clients look their best. Step-by-step discussions and helpful illustrations teach you the techniques you need to shoot outdoor portraits like a pro! $29.95 list, 8½x11, 128p, b&w and color photos, index, order no. 1632.

Make Money with Your Camera

David Neil Arndt

Learn everything you need to know in order to make money in photography! David Arndt shows how to take highly marketable pictures, then promote, price and sell them. Includes all major fields of photography. $29.95 list, 8½x11, 120p, 100 b&w photos, index, order no. 1639.

Guide to International Photographic Competitions

Dr. Charles Benton

Remove the mystery from international competitions with all the information you need to select competitions, enter your work, and use your results for continued improvement and further success! $29.95 list, 8½x11, 120p, b&w photos, index, appendices, order no. 1642.

Freelance Photographer's Handbook

Cliff & Nancy Hollenbeck

Whether you want to be a freelance photographer or are looking for tips to improve your current freelance business, this volume is packed with ideas for creating and maintaining a successful freelance business. $29.95 list, 8½x11, 107p, 100 b&w and color photos, index, glossary, order no. 1633.

Infrared Landscape Photography

Todd Damiano

Landscapes shot with infrared can be breathtaking and ghostly images. The author analyzes over fifty of his most compelling photographs to teach you the techniques you need to capture landscapes with infrared. $29.95 list, 8½x11, 120p, b&w photos, index, order no. 1636.

Wedding Photography: Creative Techniques for Lighting and Posing

Rick Ferro

Creative techniques for lighting and posing wedding portraits that will set your work apart from the competition. Covers every phase of wedding photography. $29.95 list, 8½x11, 128p, b&w and color photos, index, order no. 1649.

Professional Secrets of Advertising Photography

Paul Markow

No-nonsense information for those interested in the business of advertising photography. Includes: how to catch the attention of art directors, make the best bid, and produce the high-quality images your clients demand. $29.95 list, 8½x11, 128p, 80 photos, index, order no. 1638.

Lighting Techniques for Photographers

Norman Kerr

This book teaches you to predict the effects of light in the final image. It covers the interplay of light qualities, as well as color compensation and manipulation of light and shadow. $29.95 list, 8½x11, 120p, 150+ color and b&w photos, index, order no. 1564.

Infrared Photography Handbook

Laurie White

Covers black and white infrared photography: focus, lenses, film loading, film speed rating, batch testing, paper stocks, and filters. Black & white photos illustrate how IR film reacts. $29.95 list, 8½x11, 104p, 50 b&w photos, charts & diagrams, order no. 1419.

How to Shoot and Sell Sports Photography

David Arndt

A step-by-step guide for amateur photographers, photojournalism students and journalists seeking to develop the skills and knowledge necessary for success in the demanding field of sports photography. $29.95 list, 8½x11, 120p, 111 photos, index, order no. 1631.

How to Operate a Successful Photo Portrait Studio

John Giolas

Combines photographic techniques with practical business information to create a complete guide book for anyone interested in developing a portrait photography business (or improving an existing business). $29.95 list, 8½x11, 120p, 120 photos, index, order no. 1579.

Computer Photography Handbook

Rob Sheppard

Learn to make the most of your photographs using computer technology! From creating images with digital cameras, to scanning prints and negatives, to manipulating images, you'll learn all the basics of digital imaging. $29.95 list, 8½x11, 128p, 150+ photos, index, order no. 1560.

Achieving the Ultimate Image

Ernst Wildi

Ernst Wildi teaches the techniques required to take world class, technically flawless photos. Features: exposure, metering, the Zone System, composition, evaluating an image, and more! $29.95 list, 8½x11, 128p, 120 b&w and color photos, index, order no. 1628.

Black & White Portrait Photography

Helen T. Boursier

Make money with b&w portrait photography. Learn from top b&w shooters! Studio and location techniques, with tips on preparing your subjects, selecting settings and wardrobe, lab techniques, and more! $29.95 list, 8½x11, 128p, 130+ photos, index, order no. 1626

The Beginner's Guide to Pinhole Photography

Jim Shull

Take pictures with a camera you make from stuff you have around the house. Develop and print the results at home! Pinhole photography is fun, inexpensive, educational and challenging. $17.95 list, 8½x11, 80p, 55 photos, charts & diagrams, order no. 1578.

Stock Photography

Ulrike Welsh

This book provides an inside look at the business of stock photography. Explore photographic techniques and business methods that will lead to success shooting stock photos — creating both excellent images and business opportunities. $29.95 list, 8½x11, 120p, 58 photos, index, order no. 1634.

Profitable Portrait Photography

Roger Berg

A step-by-step guide to making money in portrait photography. Combines information on portrait photography with detailed business plans to form a comprehensive manual for starting or improving your business. $29.95 list, 8½x11, 104p, 100 photos, index, order no. 1570

Professional Secrets for Photographing Children

Douglas Allen Box

Covers every aspect of photographing children on location and in the studio. Prepare children and parents for the shoot, select the right clothes capture a child's personality, and shoot story book themes. $29.95 list, 8½x11, 128p, 74 photos, index, order no. 1635.

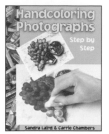

Handcoloring Photographs Step-by-Step

Sandra Laird & Carey Chambers

Learn to handcolor photographs step-by-step with the new standard in handcoloring reference books. Covers a variety of coloring media and techniques with plenty of colorful photographic examples. $29.95 list, 8½x11, 112p, 100+ color and b&w photos, order no. 1543.

Special Effects Photography Handbook

Elinor Stecker-Orel

Create magic on film with special effects! Little or no additional equipment required, use things you probably have around the house. Step-by-step instructions guide you through each effect. $29.95 list, 8½x11, 112p, 80+ color and b&w photos, index, glossary, order no. 1614.

Fine Art Portrait Photography

Oscar Lozoya

The author examines a selection of his best photographs, and provides detailed technical information about how he created each. Lighting diagrams accompany each photograph. $29.95 list, 8½x11, 128p, 58 photos, index, order no. 1630.

Family Portrait Photography

Helen Boursier

Learn from professionals! Includes: marketing family portraits, advertising, working with clients, posing, lighting, and selection of equipment. Includes images from a variety of top portrait shooters. $29.95 list, 8½x11, 120p, 123 photos, index, order no. 1629.

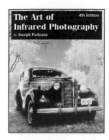

The Art of Infrared Photography, *4th Edition*

Joseph Paduano

Practical guide to the art of infrared photography. Tells what to expect and how to control results. Includes: anticipating effects, color infrared, digital infrared, using filters, focusing, developing, printing, handcoloring, toning, and more! $29.95 list, 8½x11, 112p, order no. 1052

The Art of Portrait Photography

Michael Grecco

Michael Grecco reveals the secrets behind his dramatic portraits which have appeared in magazines such as *Rolling Stone* and *Entertainment Weekly*. Includes: lighting, posing, creative development, and more! $29.95 list, 8½x11, 128p, order no. 1651.

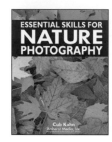

Essential Skills for Nature Photography

Cub Kahn

Learn all the skills you need to capture landscapes, animals, flowers and the entire natural world on film. Includes: selecting equipment, choosing locations, evaluating compositions, filters, and much more! $29.95 list, 8½x11, 128p, order no. 1652.

Photographer's Guide to Polaroid Transfer

Christopher Grey

Step-by-step instructions make it easy to master Polaroid transfer and emulsion lift-off techniques and add new dimensions to your photographic imaging. Fully illustrated every step of the way to ensure good results the very first time! $29.95 list, 8½x11, 128p, order no. 1653.

Black & White Landscape Photography

John Collett and David Collett

Master the art of b&w landscape photography. Includes: selecting equipment (cameras, lenses, filters, etc.) for landscape photography, shooting in the field, using the Zone System, and printing your images for professional results. $29.95 list, 8½x11, 128p, order no. 1654.

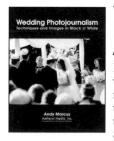

Wedding Photojournalism

Andy Marcus

Learn the art of creating dramatic unposed wedding portraits. Working through the wedding from start to finish you'll learn where to be, what to look for and how to capture it on film. A hot technique for contemporary wedding albums! $29.95 list, 8½x11, 128p, order no. 1656.

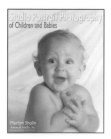

Studio Portrait Photography of Children and Babies

Marilyn Sholin

Learn to create images that will be treasured for years to come. Includes tips for working with kids at every developmental stage, from infant to pre-schooler. Features: lighting, posing and much more! $29.95 list, 8½x11, 128p, order no. 1657.

Professional Secrets of Wedding Photography

Douglas Allen Box

Over fifty top-quality portraits are individually analyzed to teach you the art of professional wedding portraiture. Lighting diagrams, posing information and technical specs are included for every image. $29.95 list, 8½x11, 128p, order no. 1658.

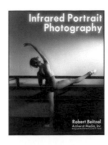

Infrared Portrait Photography

Richard Beitzel

Discover the unique beauty of infrared portraits, and learn to create them yourself. Included is information on: shooting with infrared, selecting subjects and settings, filtration, lighting, and much more! $29.95 list, 8½x11, 128p, order no. 1669.

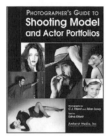

Photographer's Guide to Shooting Model & Actor Portfolios

CJ Elfont, Edna Elfont and Alan Lowy

Learn to create outstanding images for actors and models. Includes the business, photographic and professional information you need to succeed! $29.95 list, 8½x11, 128p, order no. 1659.

Black & White Photography for 35mm

Richard Mizdal

A guide to shooting and darkroom techniques! Perfect for beginning or intermediate photographers who wants to improve their skills. Features helpful illustrations and exercises to make every concept clear and easy to follow. $29.95 list, 8½x11, 128p, order no. 1670.

Photo Retouching with Adobe® Photoshop®

Gwen Lute

Designed for photographers, this manual teaches every phase of the process, from scanning to final output. Learn to restore damaged photos, correct imperfections, create realistic composite images and correct for dazzling color. $29.95 list, 8½x11, 120p, order no. 1660.

Secrets of Successful Aerial Photography

Richard Eller

Learn how to plan for every aspect of a shoot and take the best possible images from the air. Discover how to control camera movement, compensate for environmental conditions and compose outstanding aerial images. $29.95 list, 8½x11, 120p, order no. 1679.

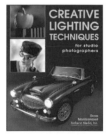

Creative Lighting Techniques for Studio Photographers

Dave Montizambert

Master studio lighting and gain complete creative control over your images. Whether you are shooting portraits, cars, table-top or any other subject, Dave Montizambert teaches you the skills you need to confidently create with light. $29.95 list, 8½x11, 120p, order no. 1666.

Professional Secrets of Nature Photography

Judy Holmes

Improve your nature photography with this must-have, full color book. Covers every aspect of making top-quality images, from selecting the right equipment, to choosing the best subjects, to shooting techniques for professional results every time.$29.95 list, 8½x11, 120p, order no. 1682.

Storytelling Wedding Photography

Barbara Box

Barbara and her husband shoot as a team at weddings. Learn how to create outstanding candids (her specialty), and combine them with formal portraits (her husband's specialty) to create a unique wedding album. $29.95 list, 8½x11, 128p, order no. 1667.

Macro and Close-up Photography Handbook

Stan Sholik

Learn to get close and capture breathtaking images of small subjects – flowers, stamps, jewelry, insects, etc. Designed with the 35mm shooter in mind, this is a comprehensive manual full of step-by-step techniques. $29.95 list, 8½x11, 120p, order no. 1686.

Fine Art Children's Photography

Doris Carol Doyle and Ian Doyle

Learn to create fine art portraits of children in black & white. Included is information on: posing, lighting for studio portraits, shooting on location, clothing selection, working with kids and parents, and much more! $29.95 list, 8½x11, 128p, order no. 1668.

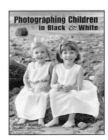

Photographing Children in Black & White

Helen T. Boursier

Learn the techniques professionals use to capture classic portraits of children (of all ages) in black & white. Discover posing, shooting, lighting and marketing techniques for black & white portraiture in the studio or on location. $29.95 list, 8½x11, 128p, order no. 1676.

Marketing and Selling Black & White Portrait Photography

Helen T. Boursier

A complete manual for adding b&w portraits to the products you offer clients (or offering exclusively b&w photography). Learn how to attract clients and deliver the portraits that will keep them coming back. $29.95 list, 8½x11, 128p, order no. 1677.

Infrared Wedding Photography

Patrick Rice, Barbara Rice & Travis HIll

Step-by-step techniques for adding the dreamy look of black & white infrared to your wedding portraiture. Capture the fantasy of the wedding with unique ethereal portraits your clients will love! $29.95 list, 8½x11, 128p, order no. 1681.

Practical Manual of Captive Animal Photography

Michael Havelin

Learn the advantages of photographing animals in captivity – as well as how to take dazzling, natural-looking photos of captive subjects (in zoos, preserves, aquariums, etc.). $29.95 list, 8½x11, 120p, order no. 1683.

Composition Techniques from a Master Photographer

Ernst Wildi

In photography, composition can make the difference between dull and dazzling. Master photographer Ernst Wildi teaches you his techniques for evaluating subjects and composing powerful images in this beautiful full color book. $29.95 list, 8½x11, 128p, order no. 1685.

Innovative Techniques for Wedding Photography

David Neil Arndt

Spice up your wedding photography (and attract new clients) with dozens of creative techniques from top-notch professional wedding photographers! $29.95 list, 8½x11, 120p, order no. 1684.

Photographing Your Artwork

Russell Hart

A step-by-step guide for taking high-quality slides of artwork for submission to galleries, magazines, grant committees, etc. Learn the best photographic techniques to make your artwork (be it 2D or 3D) look its very best! $29.95 list, 8½x11, 128p, order no. 1688.

Posing and Lighting Techniques for Studio Photographers

J.J. Allen

Master the skills you need to create beautiful lighting for portraits of any subject. Posing techniques for flattering, classic images help turn every portrait into a work of art. $29.95 list, 8½x11, 120p, order no. 1697.

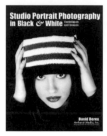

Studio Portrait Photography in Black & White

David Derex

From concept to presentation, you'll learn how to select clothes, create beautiful lighting, prop and pose top-quality black & white portraits in the studio. $29.95 list, 8½x11, 128p, order no. 1689.

Watercolor Portrait Photography: The Art of Manipulating Polaroid SX-70 Images

Helen T. Boursier

Create one-of-a-kind images with this surprisingly easy artistic technique. $29.95 list, 8½x11, 120p, order no. 1698.

AMHERST MEDIA'S CUSTOMER REGISTRATION FORM

Please fill out this sheet and send or fax to receive free information about future publications from Amherst Media.

CUSTOMER INFORMATION

DATE

NAME

STREET OR BOX #

CITY **STATE**

ZIP CODE

PHONE ()

OPTIONAL INFORMATION

I BOUGHT *TECHNIQUES FOR B&W PHOTOGRAPHY: CREATIVITY AND DESIGN* **BECAUSE**

I FOUND THESE CHAPTERS TO BE MOST USEFUL

I PURCHASED THE BOOK FROM

CITY STATE

I WOULD LIKE TO SEE MORE BOOKS ABOUT

I PURCHASE ___ **BOOKS PER YEAR**

ADDITIONAL COMMENTS

FAX to: 1-800-622-3298

①

②

Name_____
Address_____
City_____State_____
Zip_____ — _____

Place
Postage
Here

Amherst Media, Inc.
PO Box 586
Amherst, NY 14226

③